BRASIL INSPIRED_Edited by Nando Costa, Birga Meyer, Miguel Vásquez and Robert Klanten

10° 00 S
55° 00 W

TOTAL: 8,511,965 sq km • LAND: 8,456,510 sq
km • WATER: 55,455 sq km • LAND BOUNDARIES
TOTAL: 14,691 km • ARGENTINA: 1,224 km • BOLIVIA:
3,400 km • COLOMBIA: 1,643 km • FRENCH GUIANA: 673 km •
GUYANA: 1,119 km • PARAGUAY: 1,290 km • PERU: 1,560 km • SURI-
NAME: 597 km • URUGUAY: 985 km • VENEZUELA: 2,200 km •
COASTLINE: 7,491 km • MARITIME CLAIMS; CONTIGUOUS ZONE: 24
NM • CONTINEN-
TAL SHELF: 200 NM • EXCLUSIVE ECONOMIC
ZONE: 200 NM • TERRITORIAL SEA: 12 NM • ELEVATION; LOWEST
POINT: ATLAN-
TIC OCEAN 0 m • HIGHEST
POINT: PICO DA NEBLINA 3,014 m • LAND USE; ARABLE LAND:
5% • PER- MANENT CROPS: 1% • PERMANENT PASTURES: 22% • FORESTS AND WOOD-

[The remainder of the page consists of the same CIA World Factbook data for Brazil, set in small type and arranged typographically to form the outline of the country, repeated several times in varying orientations. The data include figures such as: TOTAL POPULATION 174,468,575; AGE STRUCTURE 0-14 YEARS 28.57%; GDP - PER CAPITA $6,500; PRESIDENT FERNANDO HENRIQUE CARDOSO (01/01/1995); VICE PRESIDENT MARCO MACIEL (01/01/1995); NAT'L HOLIDAY INDEPENDENCE DAY, 7 SEPTEMBER (1822); EMBASSY AVENIDA DAS NACOES, QUADRA 801, LOTE 3, DISTRITO FEDERAL CEP 70403-900, BRASILIA; etc.]

3,400
GUYANA:
NAME: 597
COASTLINE:
NM • CONTINEN-
ZONE: 200 NM • HIGHEST

BRAZIL™ APPROPRIATIONS BLUE AIR® AND GREEN AIR® PROVIDE TRANSPORTATION TO ALL
REGIONS IN THE GREATER BRAZIL CLAIM. FOR MORE INFORMATION PLEASE VISIT OUR WEBSITES :
HTTP://WWW.BLUEAIR.BR
HTTP://WWW.GREENAIR.BR

INFORMATIONAL SCHEMATIC PROVIDED BY SWEATERWEATHER.ORG INDUSTRIES. A broil™ APPROPRIATION

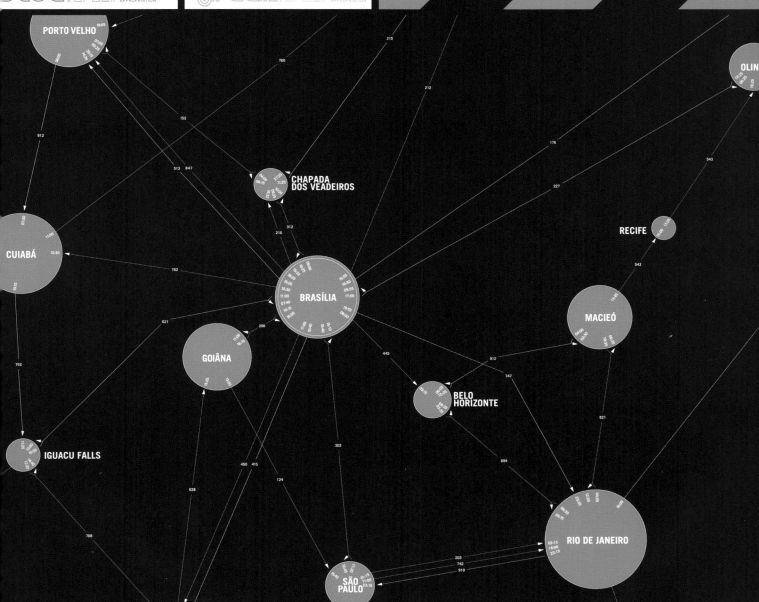

AIRPORTS : 3,264
AIRPORTS - WITH PAVED RUNWAYS; TOTAL : 570
OVER 3,047 m : 5
2,438 TO 3,047 m : 21
1,524 TO 2,437 m : 141
914 TO 1,523 m : 370
UNDER 914 m : 33
AIRPORTS - WITH UNPAVED RUNWAYS; TOTAL : 2,694
1,524 TO 2,437 m : 68
914 TO 1,523 m : 1,279
UNDER 914 m : 1,347

AIRPORTS : 1,242
AIRPORTS - WITH PAVED RUNWAYS; TOTAL : 322
OVER 3,047 m : 5
2,438 TO 3,047 m : 15
1,524 TO 2,437 m : 260
914 TO 1,523 m : 340
UNDER 914 m : 30
AIRPORTS - WITH UNPAVED RUNWAYS; TOTAL : 100
1,524 TO 2,437 m : 20
914 TO 1,523 m : 82
UNDER 914 m : 78

BRAZIL™ APPROPRIATIONS BLUE AIR® AND GREEN AIR® PROVIDE TRANSPORTATION TO ALL
REGIONS IN THE GREATER BRAZIL CLAIM. FOR MORE INFORMATION PLEASE VISIT OUR WEBSITES :
HTTP://WWW.BLUEAIR.BR
HTTP://WWW.GREENAIR.BR

INFORMATIONAL SCHEMATIC PROVIDED BY SWEATERWEATHER.ORG INDUSTRIES. A brasil™ APPROPRIATION

PORTO VELHO

CUIABÁ

IGUACU FALLS

CHAPADA
DOS VEADEIROS

BRASÍLIA

GOIÂNA

SÃO
PAULO

BELO
HORIZONTE

RIO DE JANEIRO

MACIEÓ

RECIFE

OL

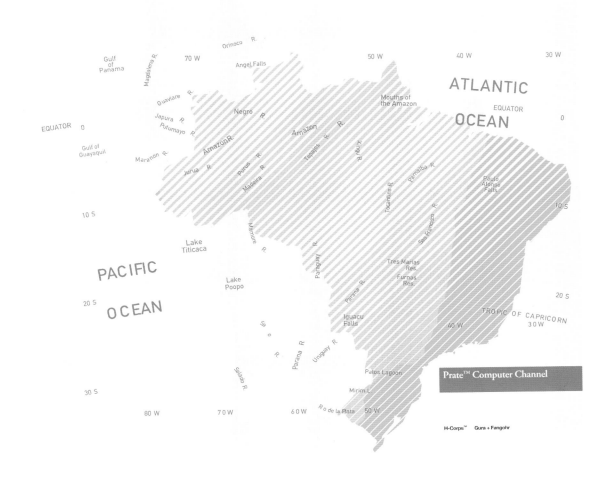

Gulf
of
Panama

Orinoco R.

70 W

50 W

40 W

30 W

Magdalena R.

Angel Falls

ATLANTIC

Guaviare R.

Mouths of
the Amazon

EQUATOR

OCEAN

Negro R.

Japura R

Amazon R.

EQUATOR 0

Putumayo

Amazon R.

Tapajos R. R.

Xingu R.

0

Gulf of
Guayaquil

Maranon R.

Amazon R.

Purus R.

Parnaiba R.

Paulo
Afonso
Falls

Jurua R.

Madeira R.

Tocantins R.

San Francisco R.

10 S

10 S

Mamore R.

Lake
Titicaca

PACIFIC

Paraguay R.

Tres Marias
Res.

Lake
Poopo

Furnas
Res.

20 S

OCEAN

Parana R.

TROPIC OF CAPRICORN

20 S

30 W

40 W

Iguacu
Falls

São

R

Parana R.

Uruguay R.

Palos Lagoon

Prate™ Computer Channel

30 S

Salado R.

Mirim L.

80 W

70 W

60 W

Rio de la Plata

50 W

H-Corps™ Gura + Fangohr

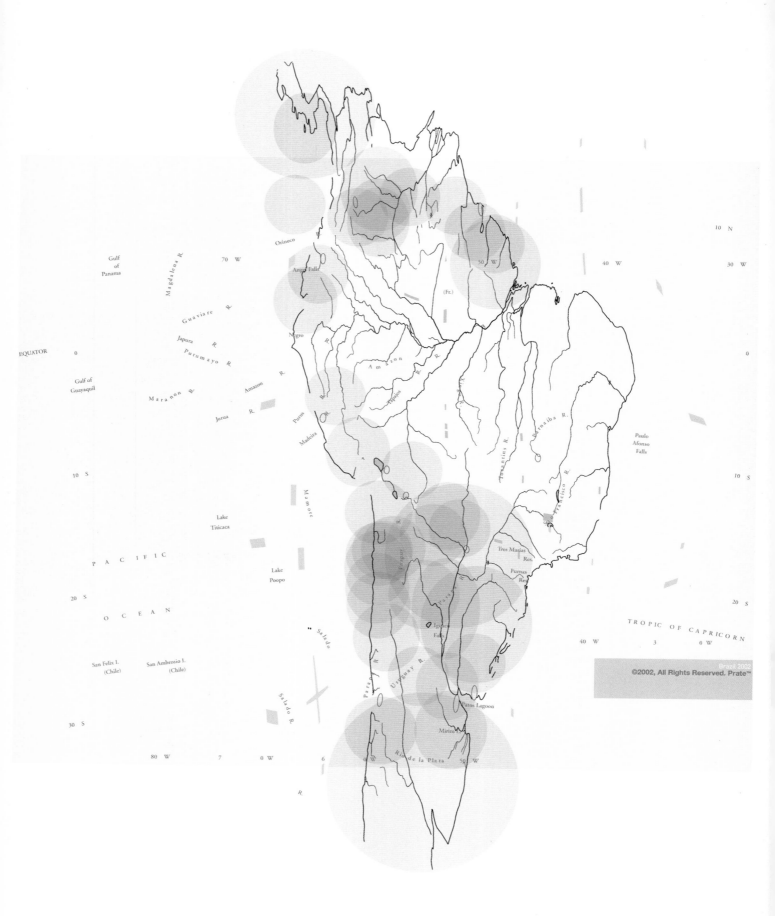

EQUATOR

0

Gulf
of
Panama

Magdalena R.

70 W

Orinoco

Angel Falls

Guaviare R.

Japura R.

Putumayo R.

Gulf of
Guayaquil

Maranon R.

Amazon R.

Jurua R.

10 S

Lake
Titicaca

P A C I F I C

20 S

O C E A N

San Felix I.
(Chile)

San Ambrosio I.
(Chile)

30 S

80 W

7

0 W

6

Negro R.

Amazon

Tapajos R.

Purus R.

Madeira R.

M a m o r e

Lake
Poopo

Salado

Salado R.

Parana R.

Paraguay R.

Uruguay R.

Iguacu
Falls

Parana R.

Rio de la Plata

0 W

50 W

Mirim

R.

50 W

(Fr.)

Tocantins R.

Paranaiba R.

Francisco R.

Tres Marias
Res.

Furnas
Res.

Patos Lagoon

10 N

50 W

40 W

30 W

Paulo
Afonso
Falls

0

10 S

T R O P I C O F C A P R I C O R N

40 W

3

0 W

20 S

BRASIL INSPIRED - IDENTITY AND CLICHÉ

Almost everyone has some kind of notion of Brazil. Filters for our perception include Samba, carnival, soccer and rain forests, but also deep social differences, corruption and pollution. This book doesn't try to use these clichés as a design template. Rather, it investigates Brazilian creative identity and how that identity could unfold in the future.

In doing so, the boundary between identity and cliché is blurred because identity is the sum of our daily experience, of tradition and also of our goals. Identity has a tendency to be unconscious because its components constantly surround us. Thus, we often become aware of it only when compared to outsiders. For this reason Brasil Inspired not only features Brazilian designers, but also the work of South and North Americans, Asians and Europeans, who have tried to communicate their idea of a Brazilian identity.

Economically-speaking Brazil is strongly oriented toward the US and Europe. Almost every globally relevant corporation has a local Brazilian office. That makes Brazil one of the most important trading partners worldwide. Western consumer goods that are produced and distributed in Brazil are packaged, advertised and sold according to Western criteria. The inspiration for these goods comes from North America and Europe. On some Latin American TV channels one can see more blondes than on Swedish television. This is a fact, but does that make it an element of Latin American identity? The industrial nations that are being imitated or made into clichés mostly view these attempts at emulation with the sort of benevolence of a master, who has taught its dog a new trick. But a partner with whom one sees eye-to-eye doesn't fetch sticks.

One can't ignore that there is another dynamic at work. Let's call this the "pizza effect." Cultured tourists prefer to eat local cuisine, but to local cooks, grandma's specialties are old-fashioned and no challenge to make. Local cooks would rather make international standards. Similarly, some local designers like to give their work all too obvious British, Japanese or Swiss touches.

Brazil is influenced by diverse local traditions and folklore. The country is a distinctive mix of all of the cultures that immigrated into it as well as the indigenous culture of its Indians. Brazil has a design tradition that is loosely based on Bauhaus principles and from which artists, who are internationally significant in all areas, have been born. Brasil Inspired can't and doesn't want to be a dazzling kaleidoscope of design from Brazil. It also can't and doesn't want to be a collection of postcard motifs of artistic workmanship. Instead, the book concentrates on separating the specific from the general as well as on creating awareness for the blurry crossover between Brazilian identity and cliché. By looking at Brazil in this way, we hope that we can create a sensibility that can be applied to other areas as well. Ideally, readers of Brasil Inspired will think twice before relying on preconceived ideas when it comes to investigating creative work from other countries.

Brasil Inspired largely contains work focusing on three areas: the processing and depiction of Brazilian motifs, the more abstract or personal definition of a Brazilian canon of forms and colors by various designers and the possible identification of a Brazilian variety of commercial art.

The idea for Brasil Inspired comes from the young Brazilian designer Nando Costa (Hungryfordesign, Nakd). Miguel Vasquez (Masa) and Birga Meyer (Die Gestalten Verlag) helped to realize it in this form. This book also contains accompanying interviews with the designers Clarissa Tossin (A'), Linn Rehman Costa, fêmur, Mateus de Paula Santos (Lobo) and Tonho (Quinta-Feira), who work in Brazil in various contexts and who report on their backgrounds as well as their daily lives as designers in the country.

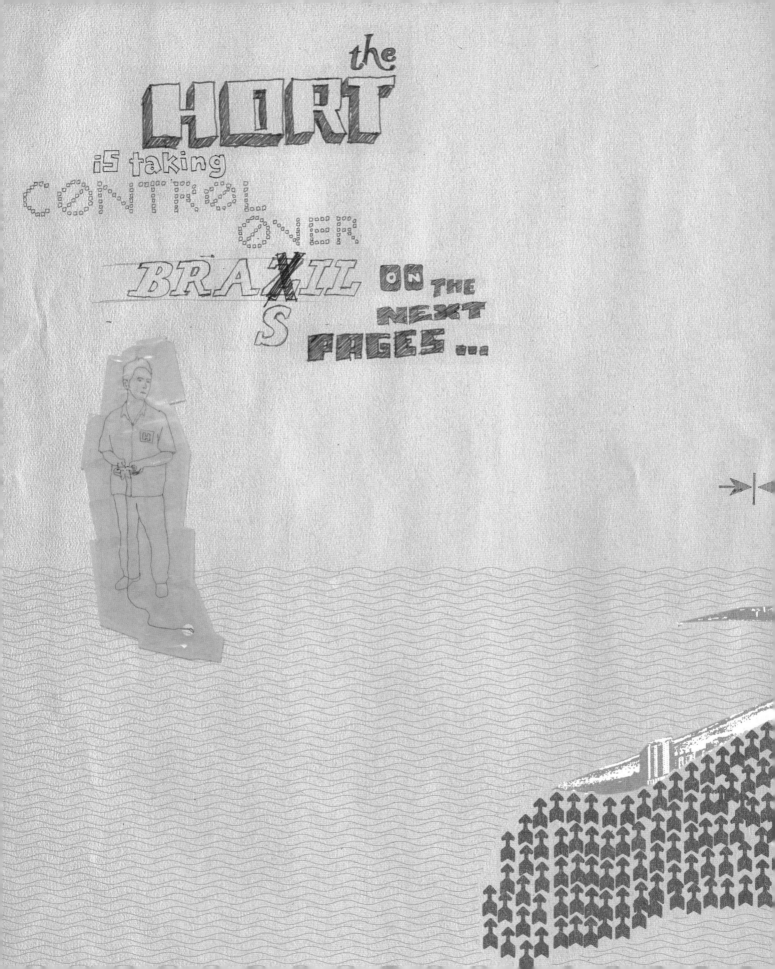

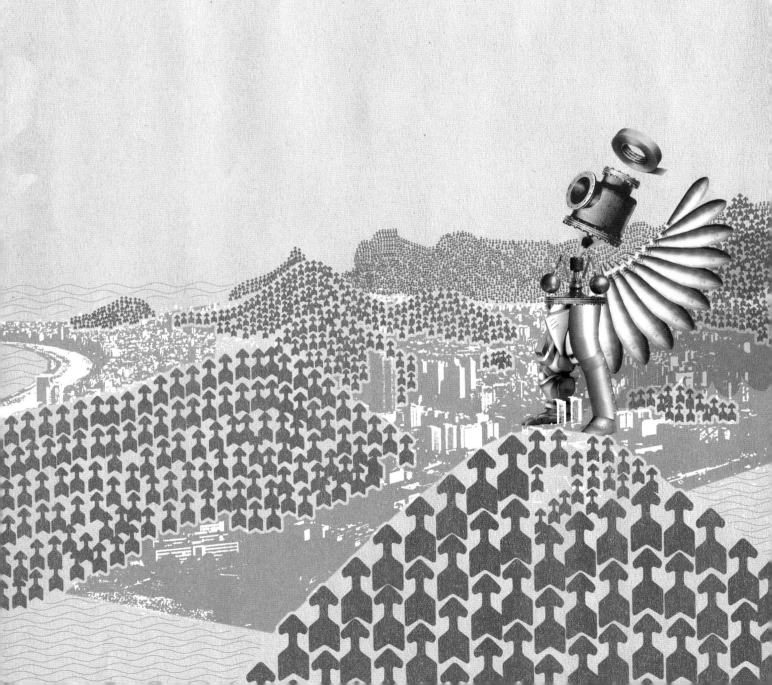

A PROJECT
DESIGNED AT
EIKESGRAFISCHERHORT.COM
IN COOPERATION WITH
HORT.ORG.UK
& BOLZERS.COM

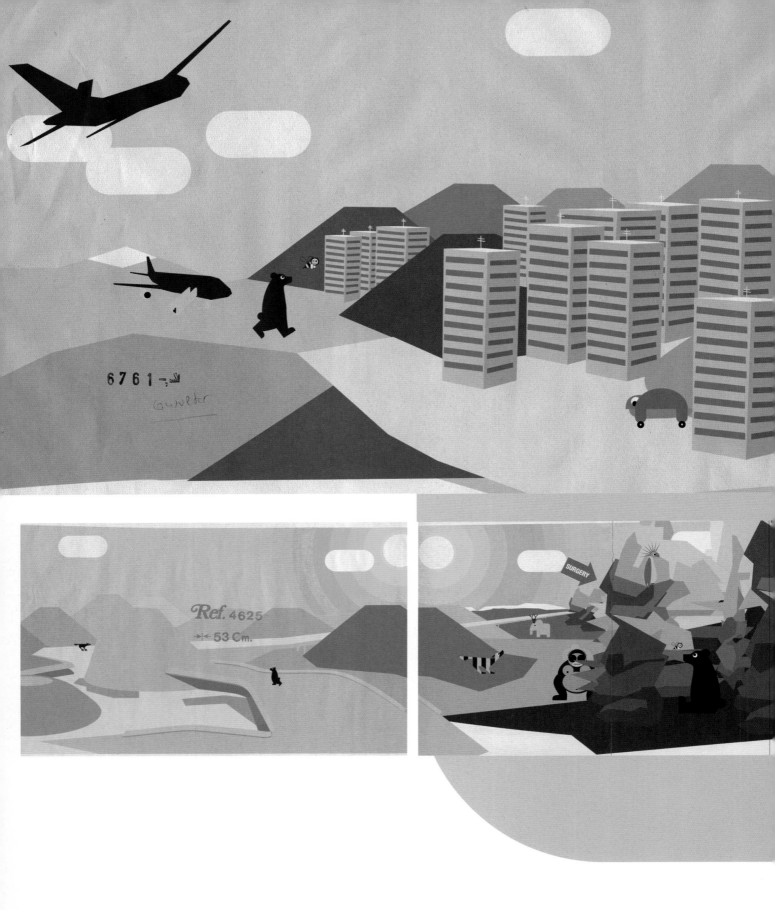

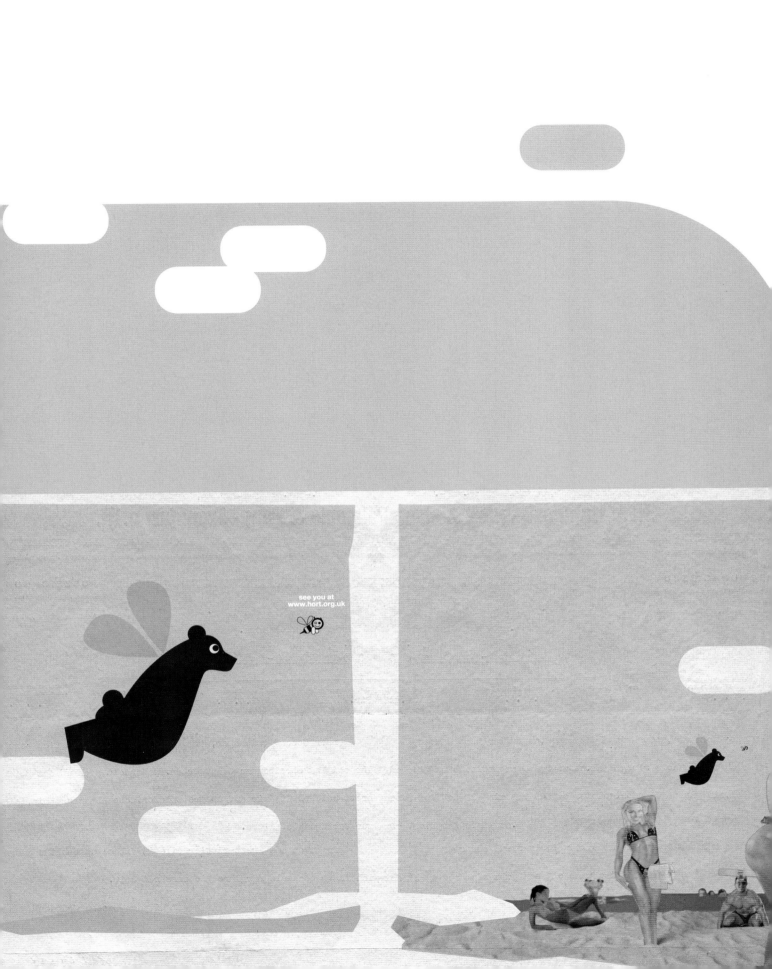

see you at
www.hort.org.uk

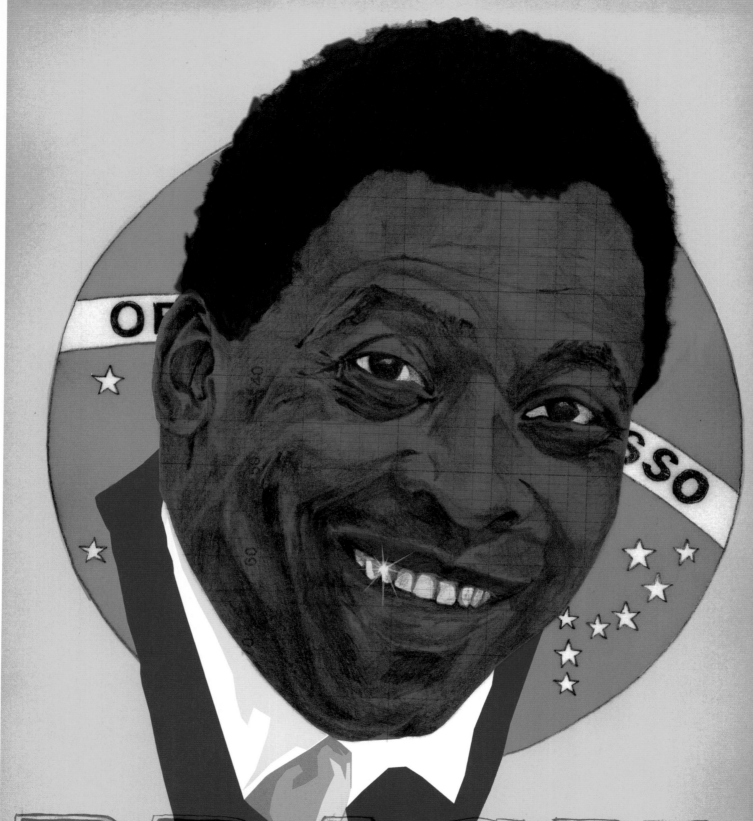

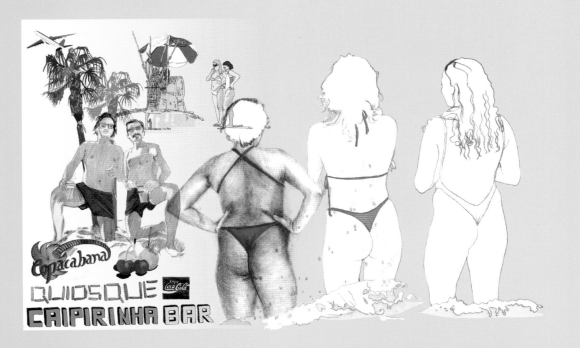

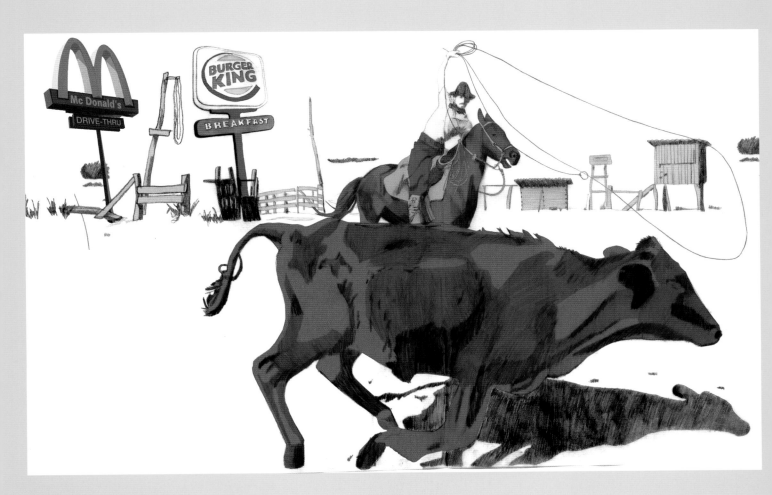

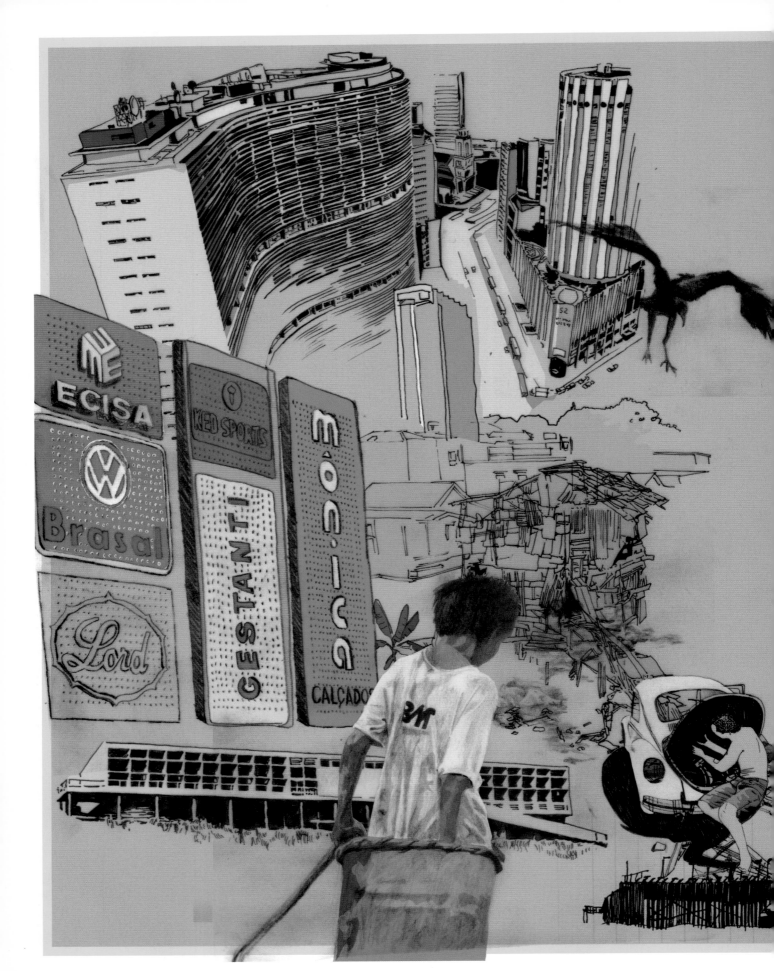

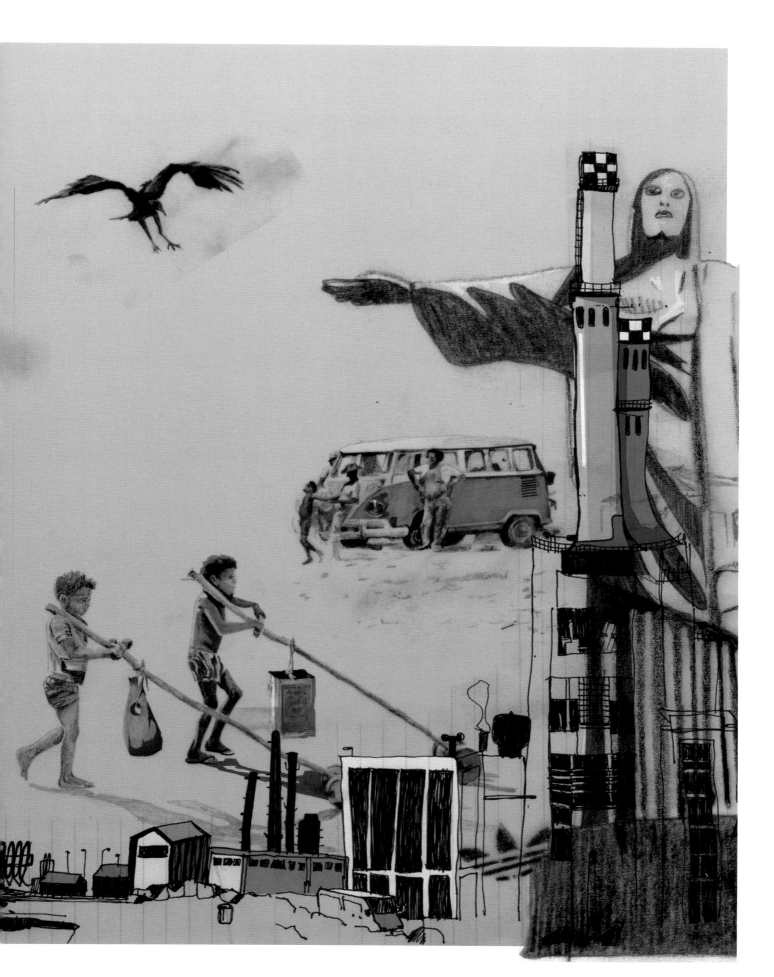

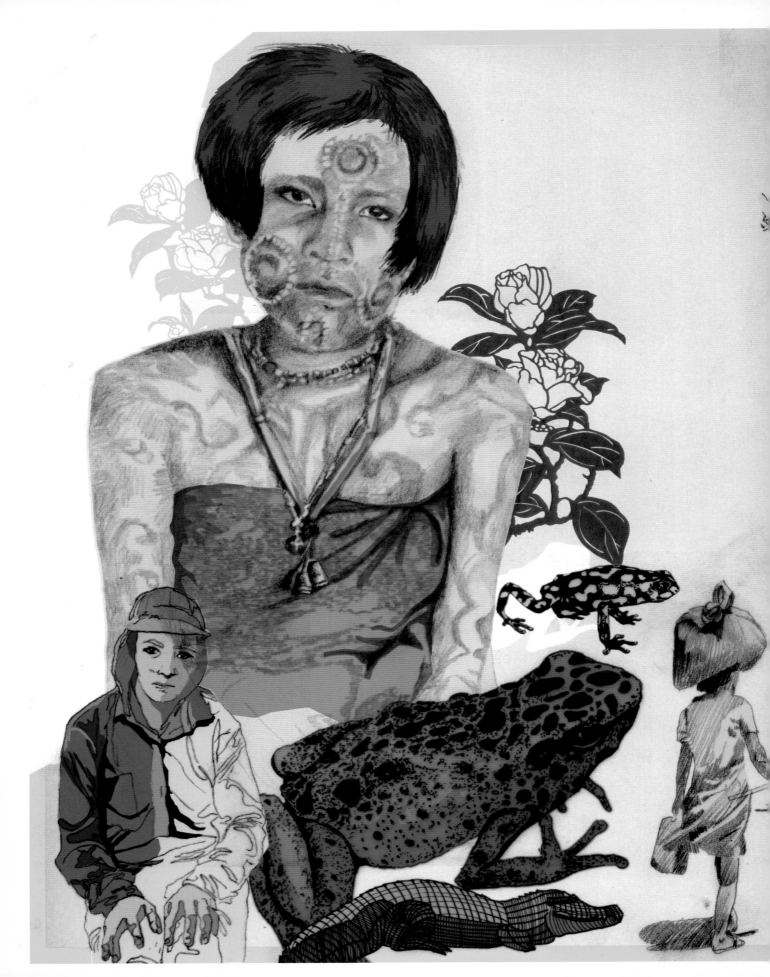

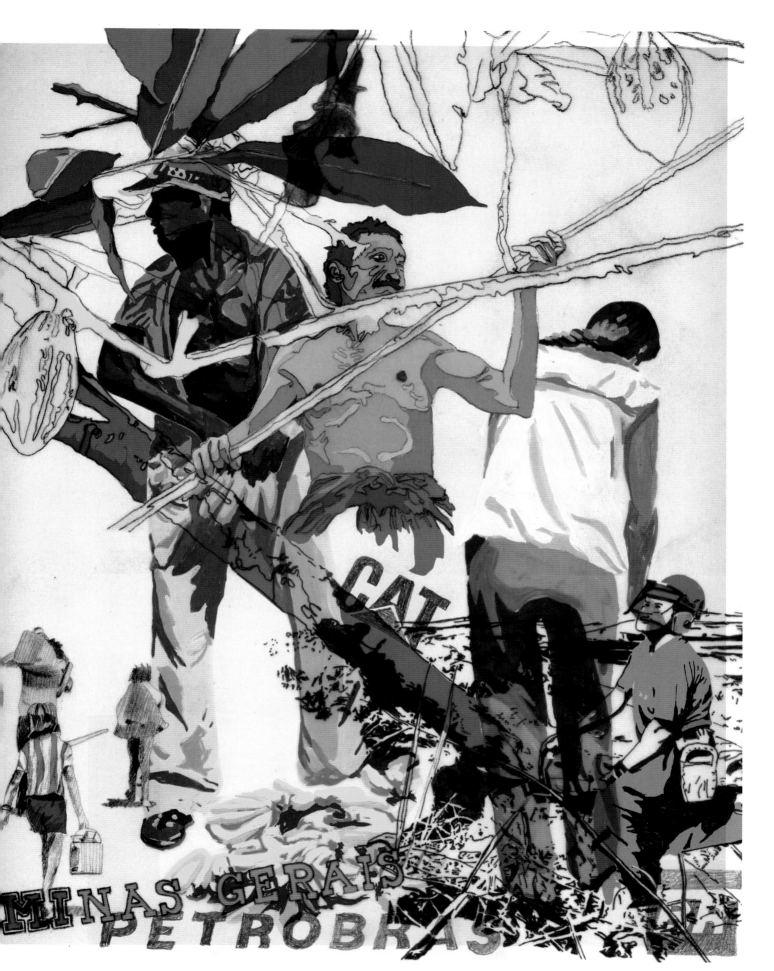

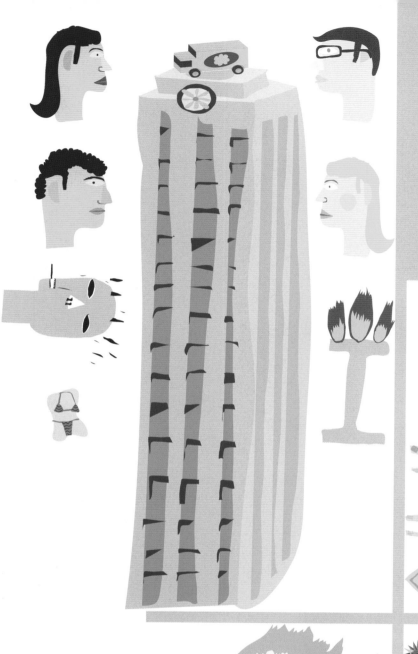
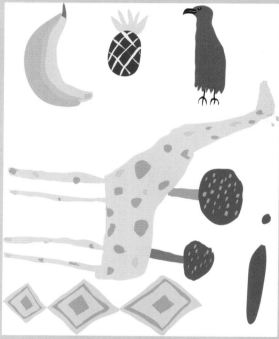
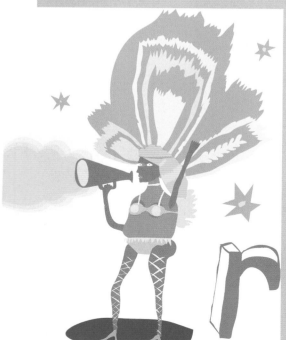

CARACU COM OVO 1,
CE 0,43 GEMADA 1,2
PIZZA 1,0 MEDIA 2,3
COPO VINHO 3,50
CHOPP 1,00 anches

CANTINHO DA BOÇA

AGUARDENTE DE CAN

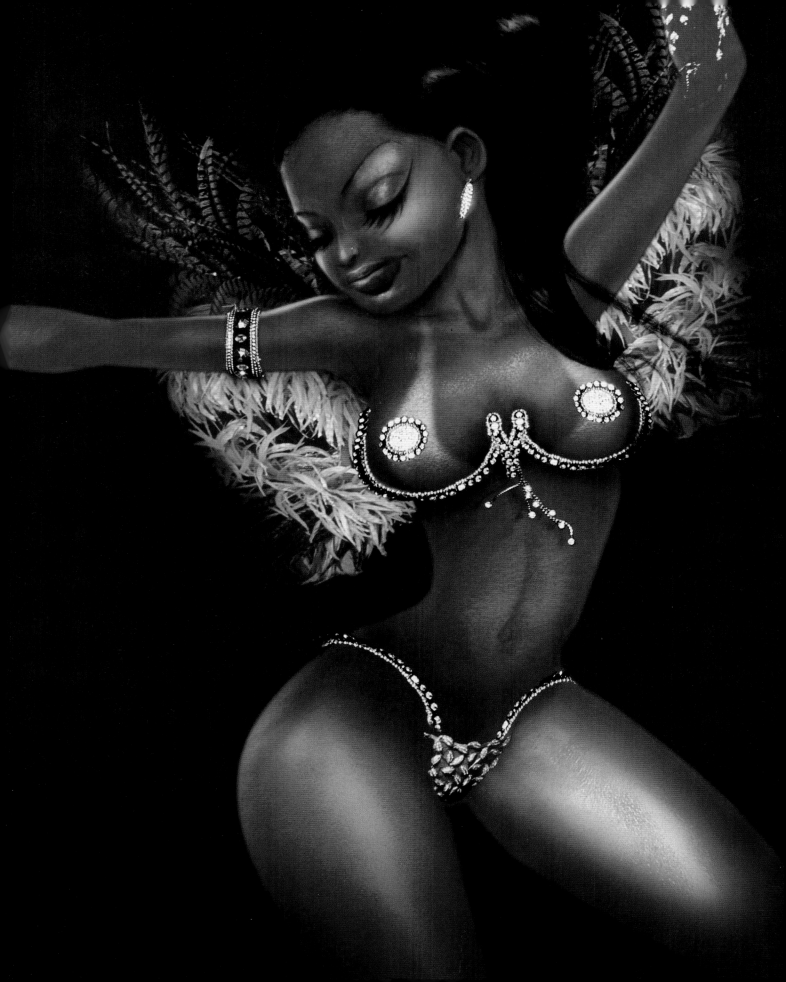

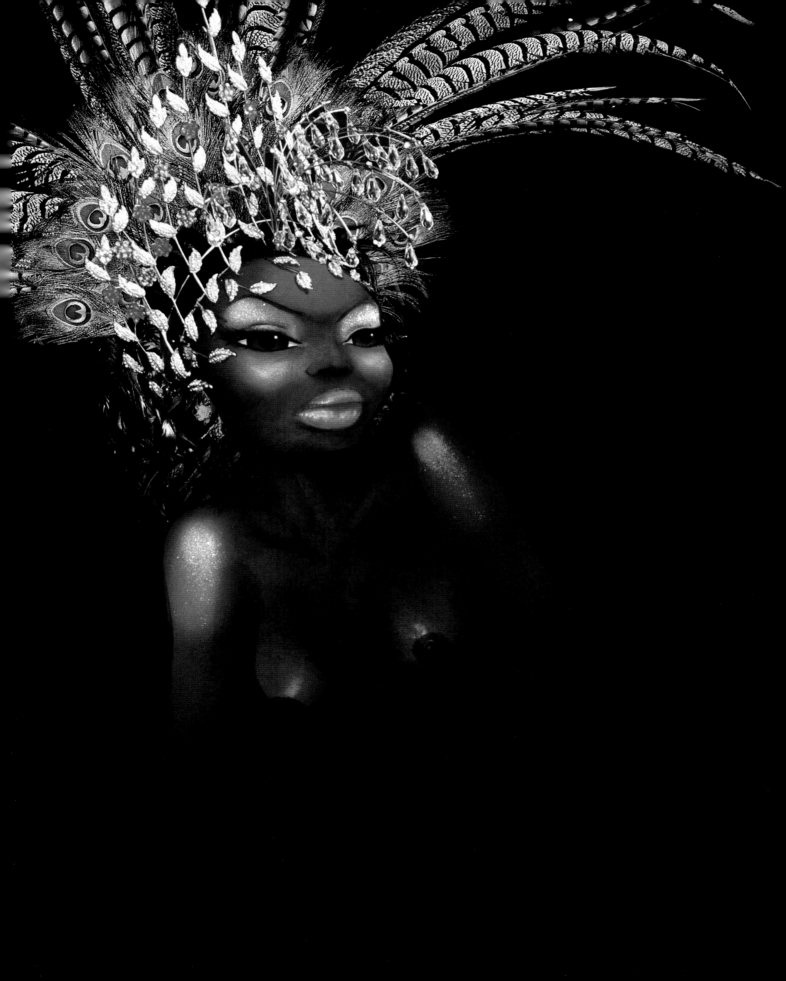

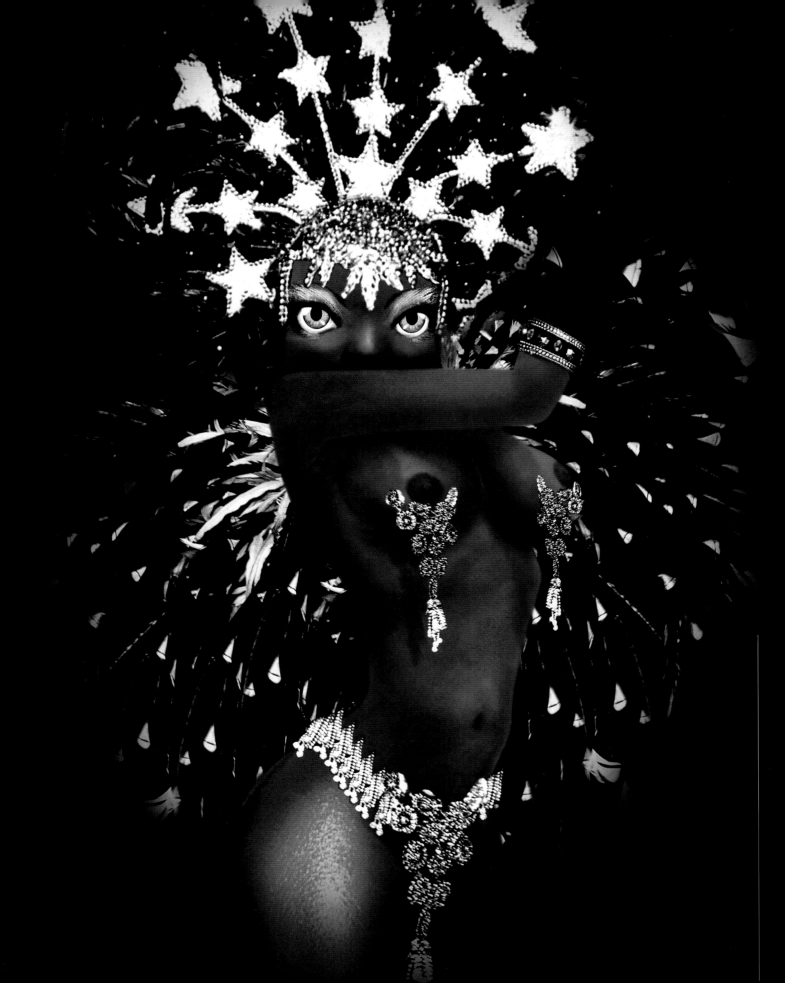

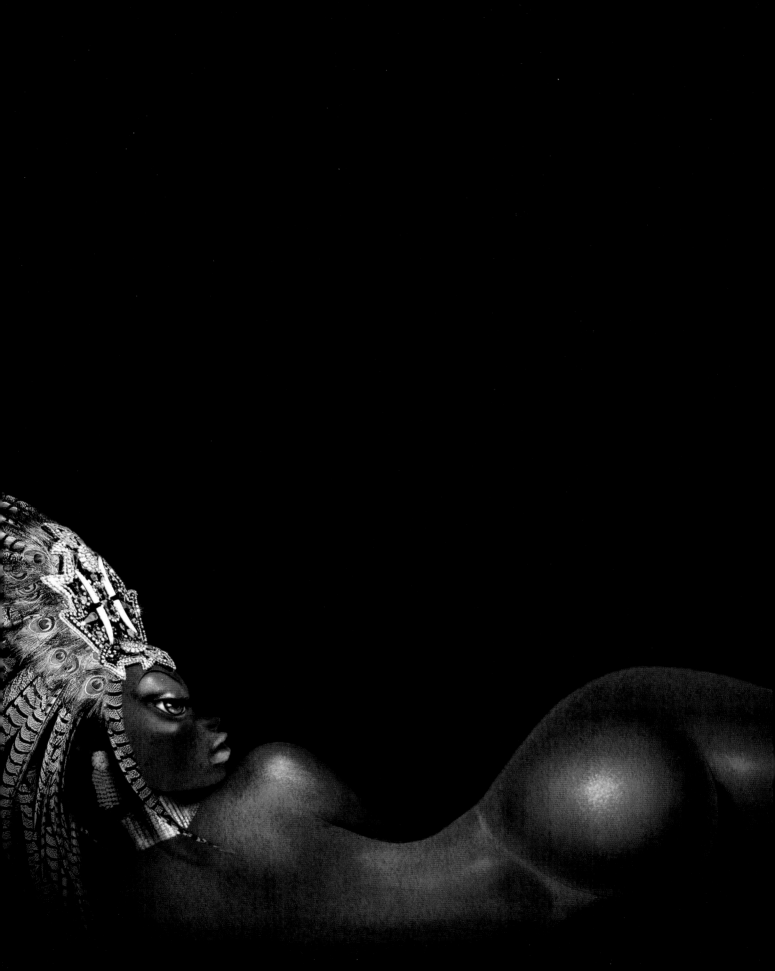

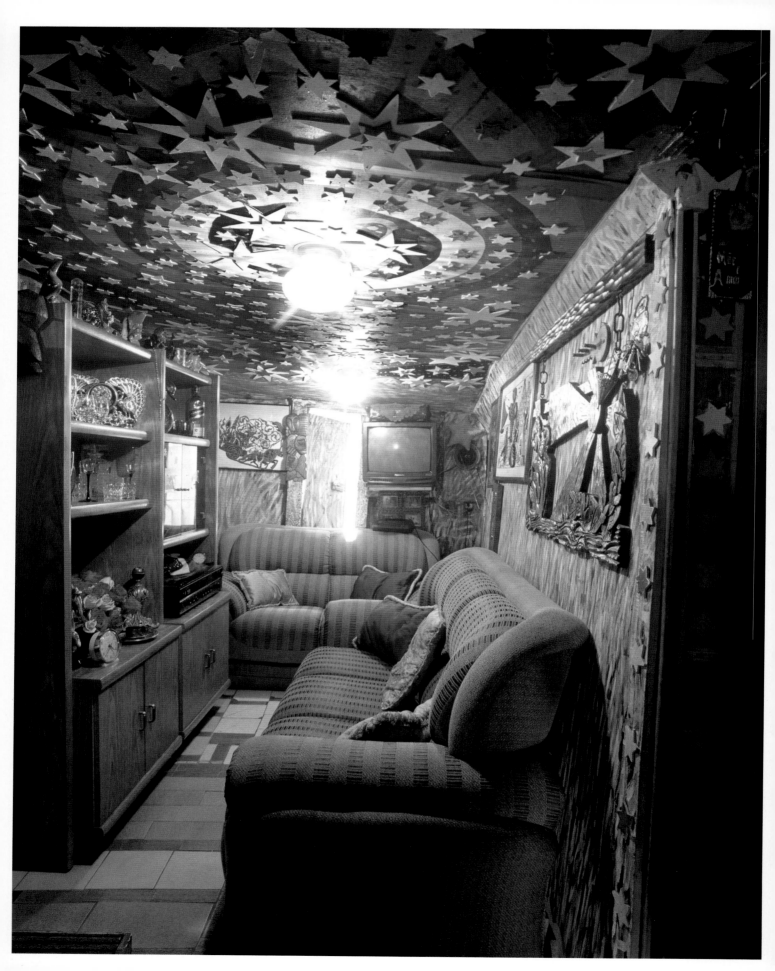

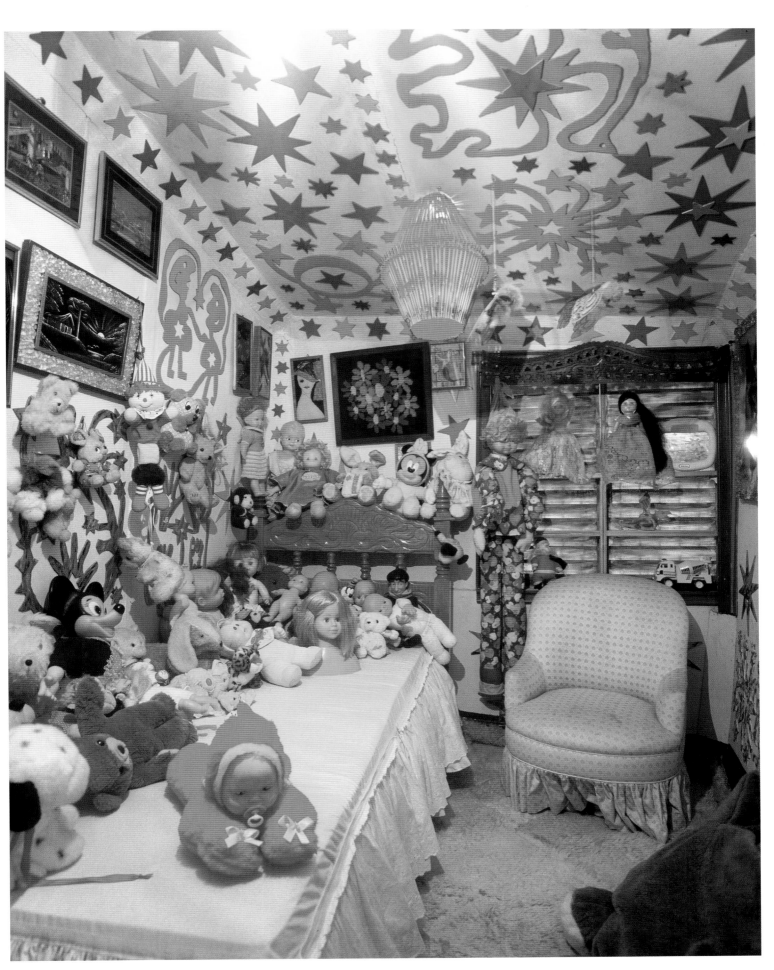

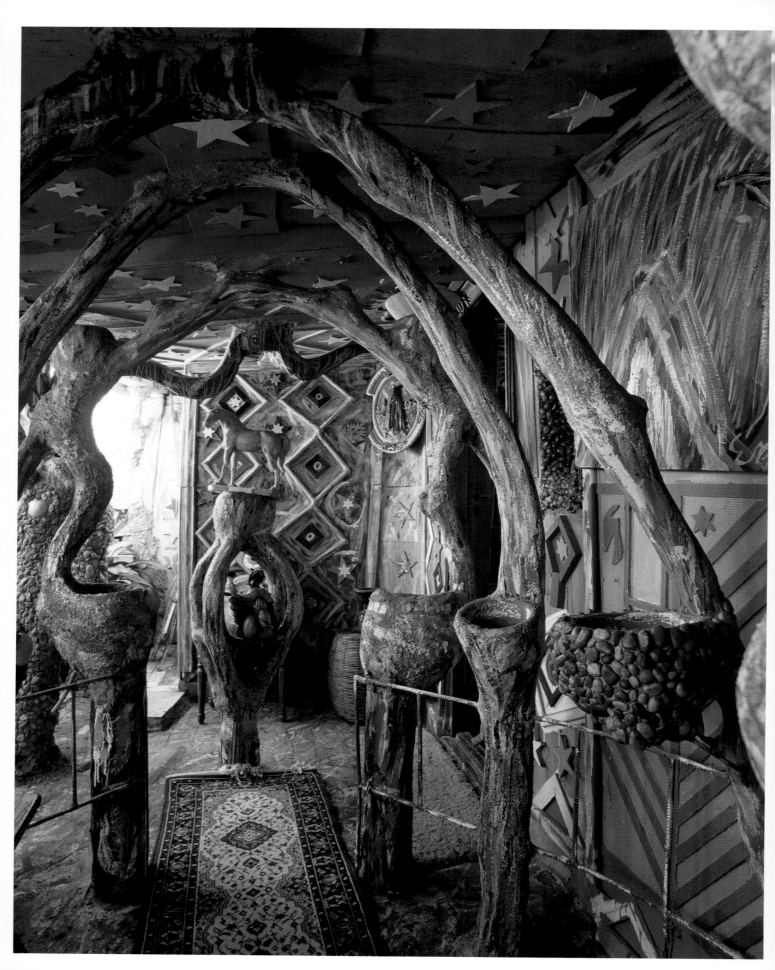

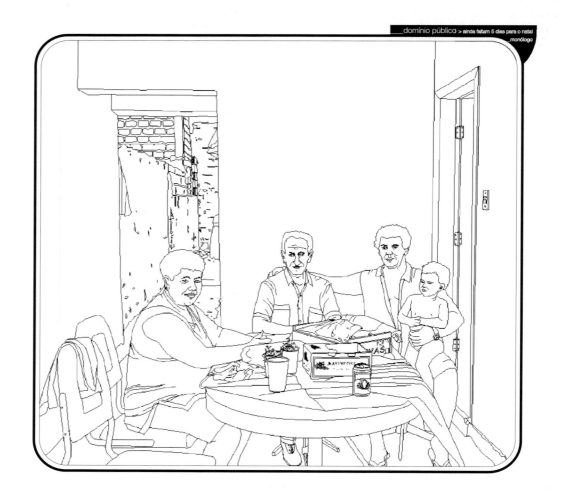

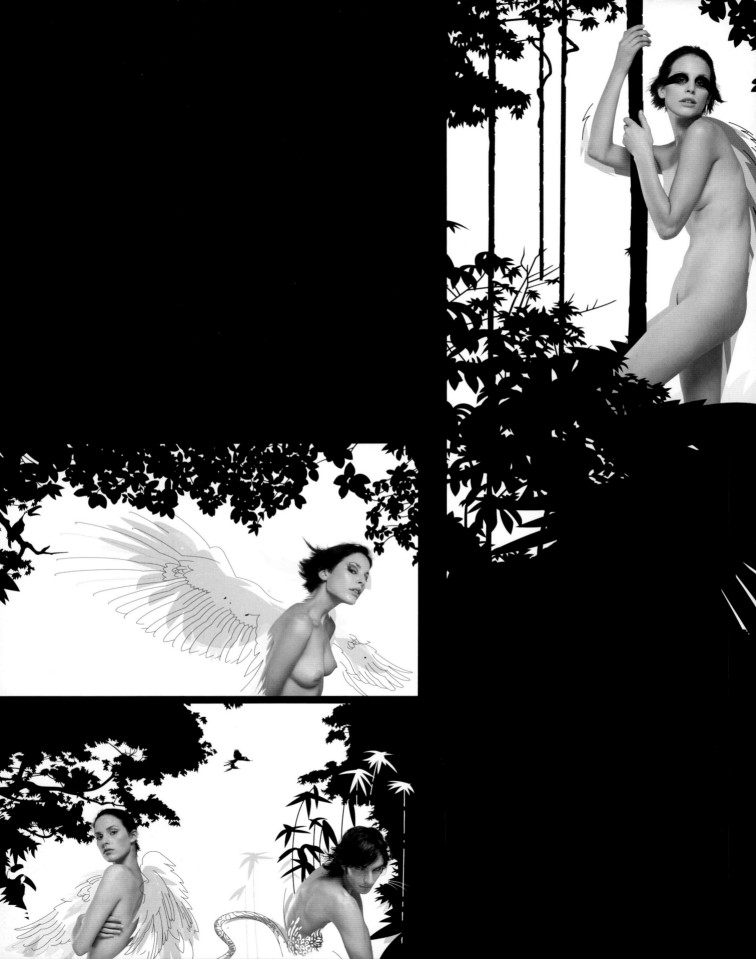

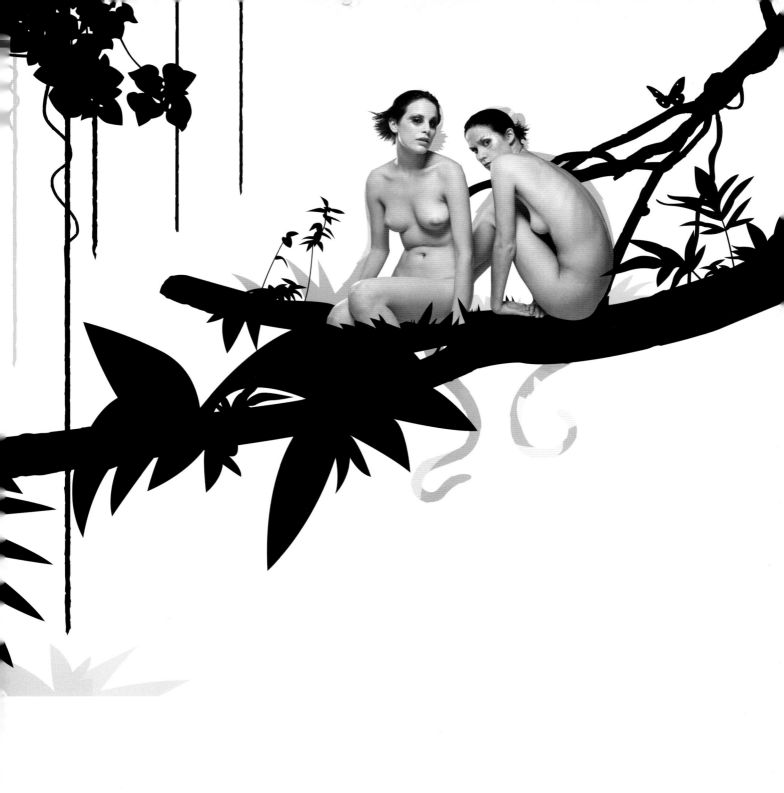

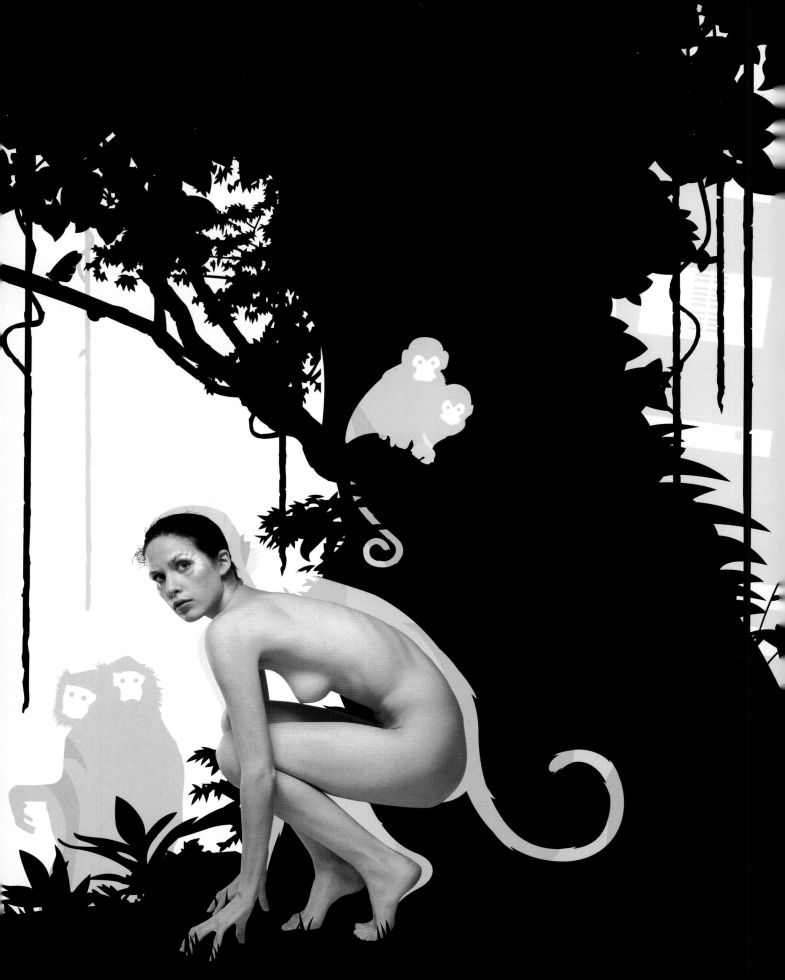

ISBN 0 7206 3238 8

there is
a lot more
than
Soccer

in

BRASIL

PLAY THE PELE WAY!

PLAY THE PELE WAY!

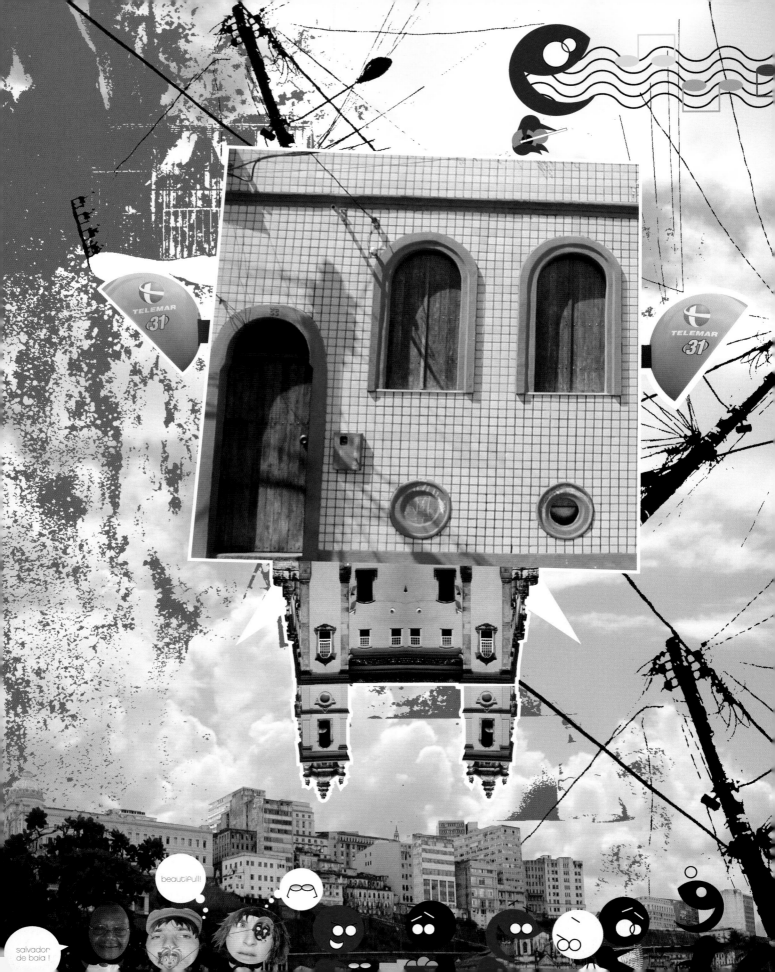

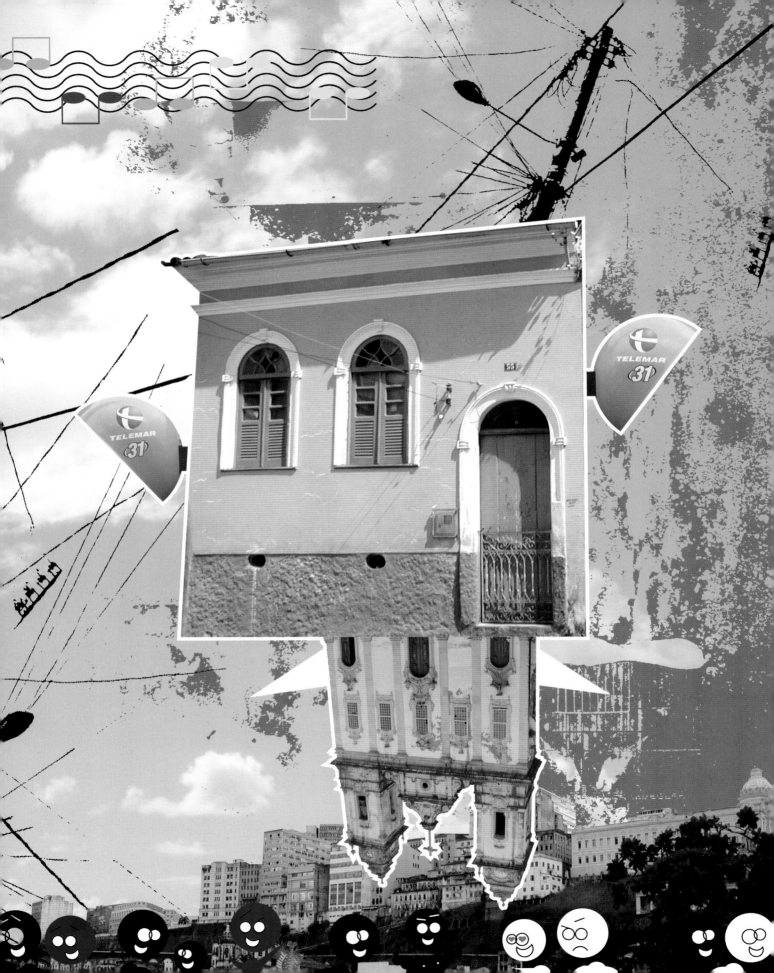

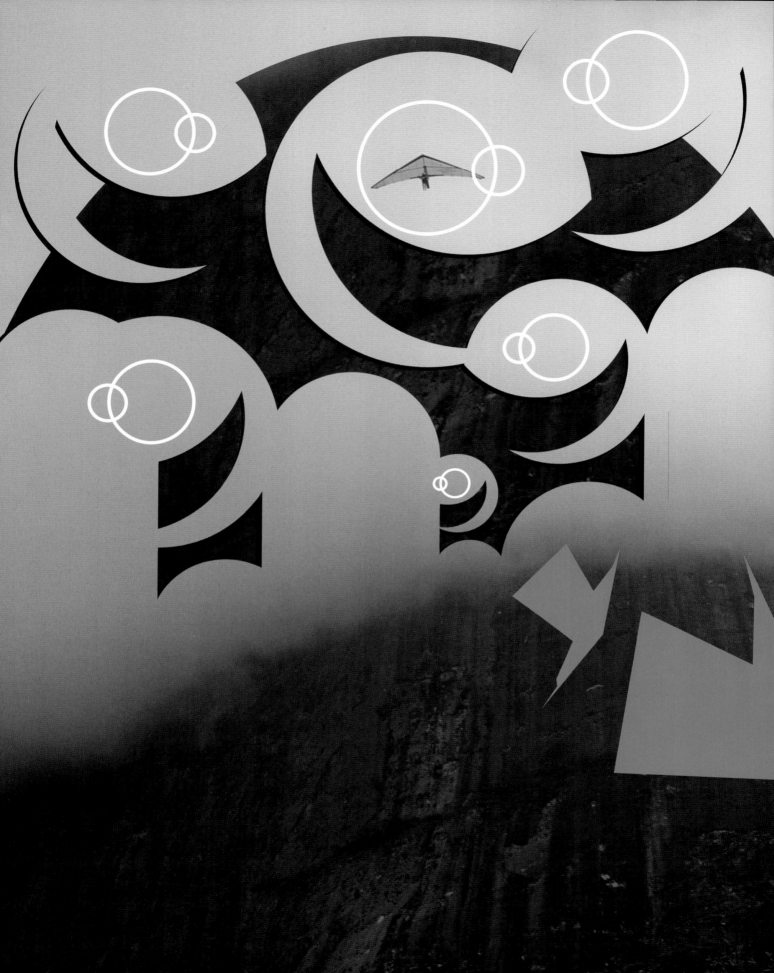

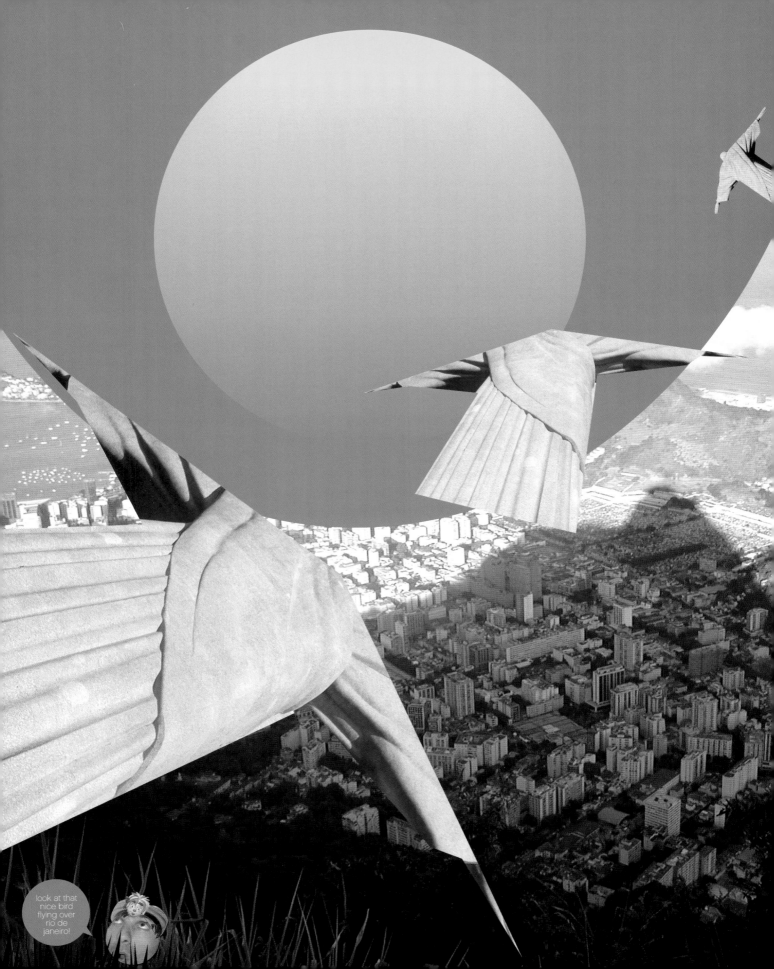

look at that nice bird flying over rio de janeiro!

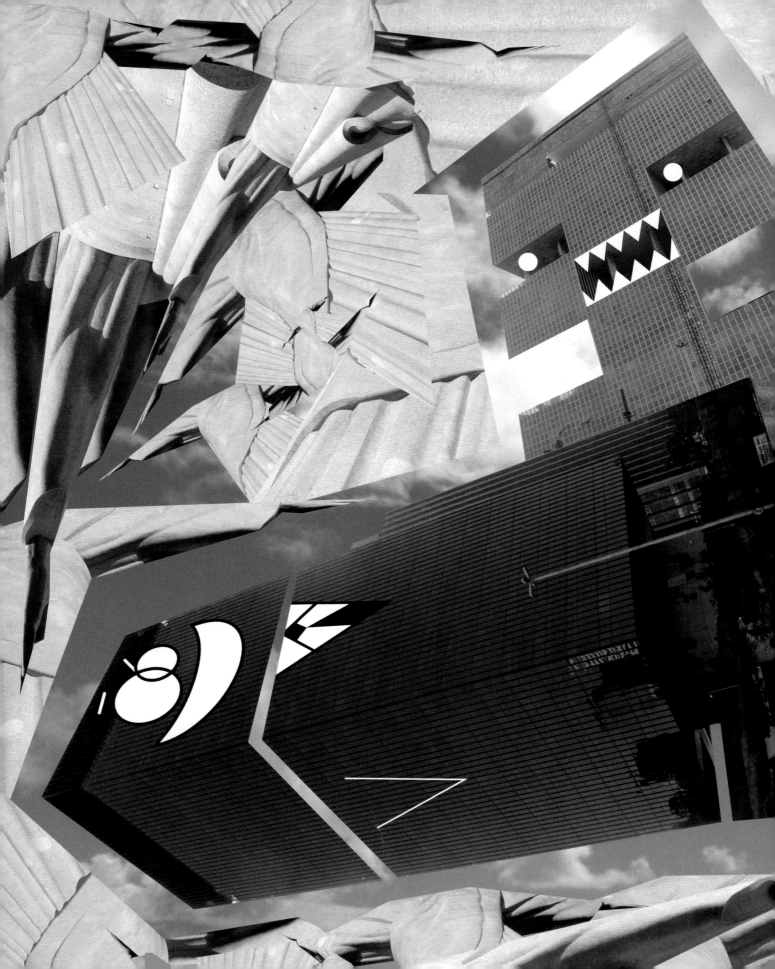

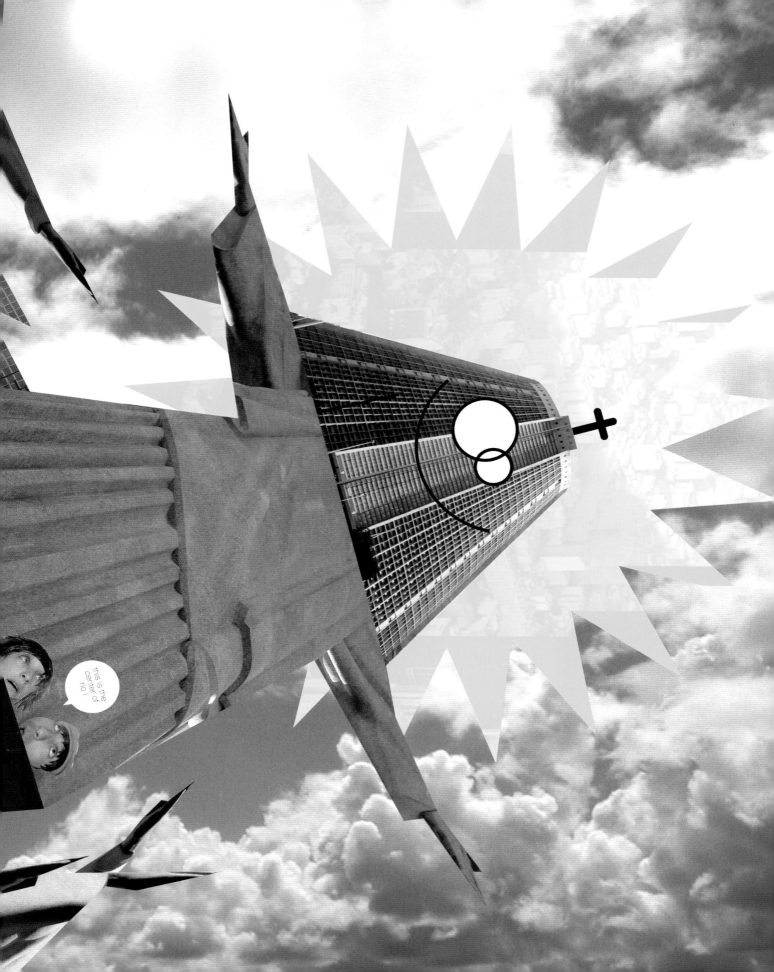

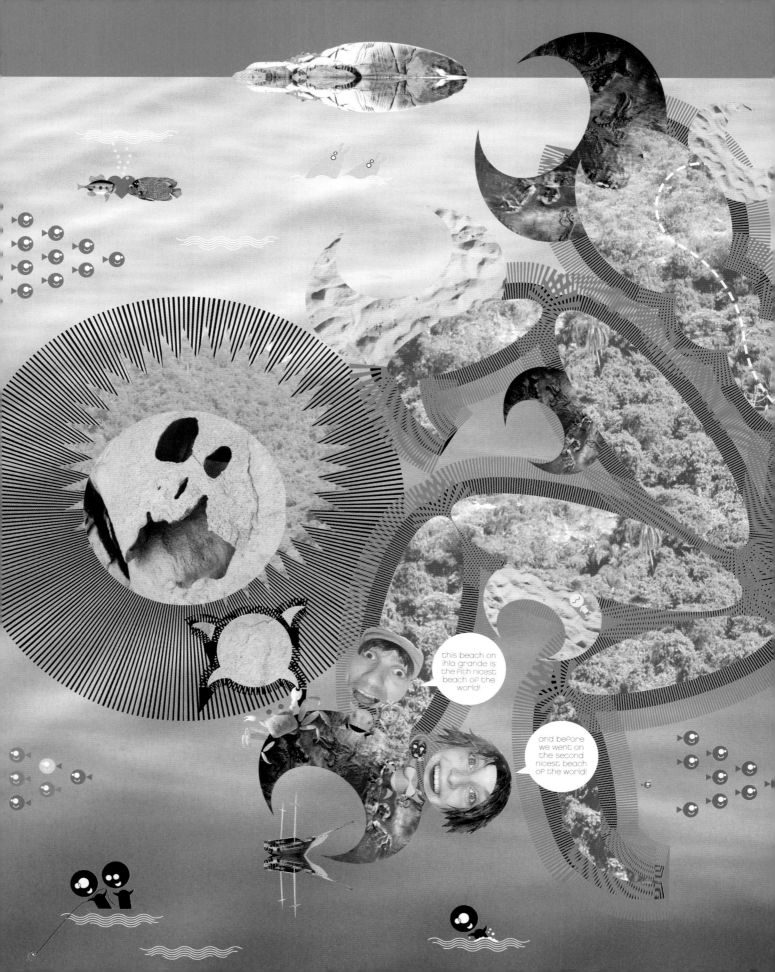

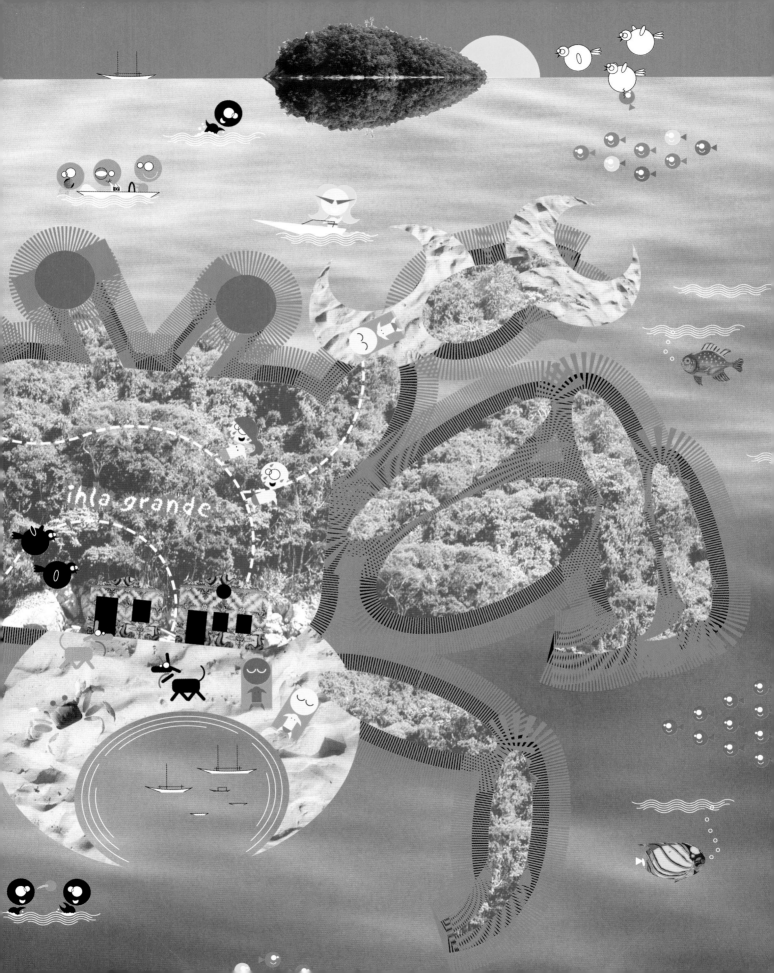

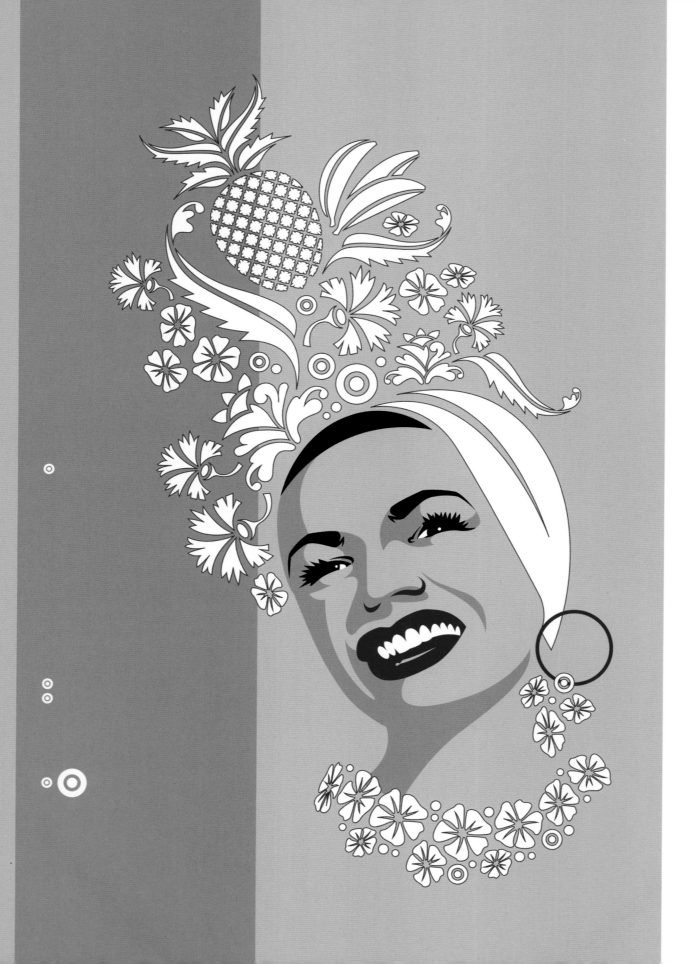

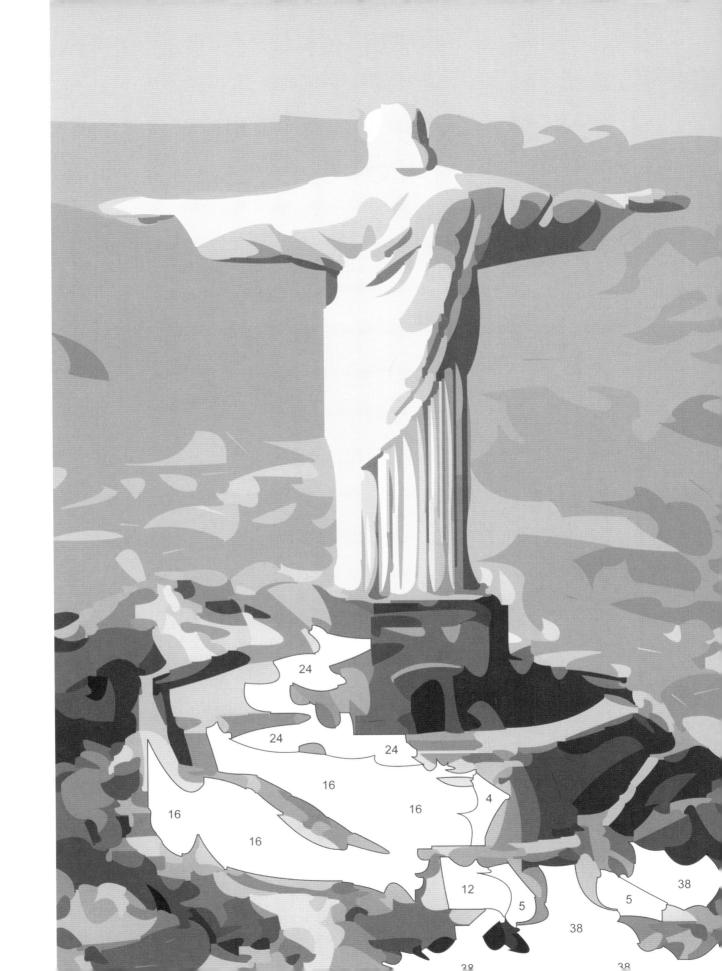

WHAT IS YOUR BACKGROUND, WHO DO YOU CONSIDER YOUR PERSONAL INFLUENCES?

I'm part of the 3rd generation in Brazil of an Italian family of immigrants that came here escaping the poverty that affected Italy during its unification period. They settled in the south of Brazil, where I was born. I lived in Caxias do Sul for 11 years.

My drawing skills weren't good enough to make me go on with my art lessons in my childhood.

My fingers stopped working in my first piano recital. When I tried to play the guitar I was told my hands were too small for that.

I insisted on being a ballet dancer even if my body wasn't cut out for that.

Then my family moved to Brasilia, and I lived there for 10 years.

I used to write a tag "Trash" on all public and private walls of most of the blocks of "Asa Norte" in Brasilia. When my first can of purple spray paint ran out I stopped doing that.

My mother never let me hang out with those "black-clothed boys" that love Joy Division. When grunge came into the scene I was a bit old to have fun.

I worked with photography for 3 years until I realized that the computer would be my perfect tool.

At 21, I came to São Paulo to focus on my professional life, and I've been here since.

I should thank life for giving me something to say before actually knowing how to say it!

WHICH NON-DESIGN INFLUENCES DO YOU CONSIDER TO BE IMPORTANT (E.G. MUSIC, FINE ARTS, VIDEO GAMES, ETC.)?

I consider my non-design influences more important than those related to design.

Actually, design for me is as related to aesthetic choices as it is to function and communication. The more open your aesthetic perception is (and not only visual perception), the more you can produce good quality work. So, accurate aesthetic perception isn't everything, but it helps to find new associations between your references and what you have to do OR it helps to find beauty where no one has seen it before.

Hmm, ok. I'll point out some works / names even though I don't think a list can describe all my references. The thing that really matters is WHAT these works / people bring out in me. That's all...

Carsten Nicolai aka Noto (especially Telefunken), Golan Levin (especially Telesymphony), John Maeda, the photographers Adam Fuss, Geraldo de Barros, Ricard Misrach, Sonic Youth, Stereolab, Flaming Lips, the strong and young way of seeing the world by grids, numbers and simple shapes by Norm, Dextro, John Warwicker (Tomato), Yayoi Kusama (artist), Hokusai (engraver), Oscar Niemeyer (architect), Athos Bulcão (artist), Almir Mavigner (poster artist), National (my electronic experimental Brazilian Band by Bizarre Music), SND, Nelson Cavaquinho, Nobukaso Takemura, Damon e Naomi, Tortoise, FRIENDS and MANY others in all different areas that come and go AND that are not less important because they weren't listed here.

HOW DO YOU KEEP YOURSELF UP TO DATE WITH WHAT'S GOING ON? ARE DESIGN BOOKS AND MAGAZINES ACCESSIBLE?

Sure they are. Especially in São Paulo, which is a metropolis as any other in the world and the biggest city in Latin America. The only problem is that foreign books, magazines and CDs are expensive here. That is one reason why I don't buy them so often. And, unfortunately, our unstable economy doesn't help our cultural industry produce an amount of good cultural products compared to first world countries. Internet solves many problems of information at a low budget.

HOW DOES THE BRAZILIAN CREATIVE INDUSTRY FUNCTION? ARE THERE FREELANCE JOBS OR IS IT MAINLY AGENCY WORK?

Mainly agency work, but there are freelance jobs too. It depends on which segment of the creative industry you want to be in. Most small studios work for big agencies as a support for specific jobs of big clients. The editorial magazine market is huge in Brazil, but their budget is usually very low. It is, for example, impossible to support myself doing only freelance work for Brazilian magazines. Actually, I have some clients that come directly to me asking to do a logotype, website, book cover, etc., and I can balance my income with some agency work too.

HOW DO YOU BALANCE BETWEEN COMMISSIONED JOBS AND FREE, PERSONAL PROJECTS? TELL US ABOUT YOUR STRATEGY ;-).

Ahahhahahah, no strategy at all! Any tips?! Sometimes I go crazy with deadlines and many projects happening at the same time. I wish I could be commissioned for my personal projects. They're a very important part of my professional life. That's the way to keep my creation process going on. And, of course, I devote a lot of time to it.

On the other hand, the only specific attitude that I have toward commercial work is that I try to earn something more than money from these jobs. Having at least an easygoing relationship with clients is an important point. That's a good thermometer for keeping a good mood in life.

HOW DO YOU FEEL ABOUT BRAZILIAN CLICHÉS SUCH AS SAMBA, FOOTBALL, BEACH, CARNIVAL, THE AMAZON, POLLUTION, CORRUPTION?

I have no problem with obvious Brazilian references. They are pretty much part of our reality. The problem is the approach to these themes. You must have an attitude to use these references in an interesting way, and it's very rare to find works that use these clichés in a clever manner.

I'm sure my Brazilian references are present in my work in a way that is not so obvious. I believe my cultural roots are intrinsically connected to my creation process because they are part of all references that determine my perception of life. I prefer to use my personal work to create in a far-reaching way, without geographic boundaries.

But even in Brazil I've been asked before to use graphic Brazilian clichés in specific jobs. You can find people here, who think that the idea that foreign people have about Brazil is cool.

Sometimes people use clichés to be funny. Sometimes it works, sometimes it doesn't.

AH! By the way, our palm trees are not original, but were brought to Brazil by the Portuguese. Sometimes even to point out a peculiar reference one has to go deeper.

DO THESE CLICHÉS HELP OR HINDER YOUR PERCEPTION AS A DESIGNER ABROAD?

Hmmm, that's funny! It will be my pleasure to listen to your opinion on that.

I'm only doing my job as I believe it should be done. It's not clear to me what is very Brazilian in my work, and actually I'm not worried about putting these obvious Brazilian references there in a stupid way. (If I did it once it was because I was asked to do it for commercial purposes.) And, in fact, what is a Brazilian reference exactly? The palm trees? OR the Brazilian design schools that had their first structure based on Ulm principles by Max Bill?

Do you think the oppression of the USA's cultural industry doesn't affect the perception of a whole population in their own cultural habits?

I'm aware that I'm a "vector child" that started doing design with a computer the same way as many other designers from other countries. And I don't think it is a problem; it's only a historical fact of our time. It doesn't determine WHAT and HOW one can communicate something. I'm trying to find my way to do that... Maybe the most important thing in our globalized world, where cultural references are so blurred, is to try to use your own subjective references and not the generic cultural ones.

SEPULTURA SOULFLY MOLAMBO CHEGOU PRA DETONAR ESSA PORRA! HAVALERA! CAVALERA!

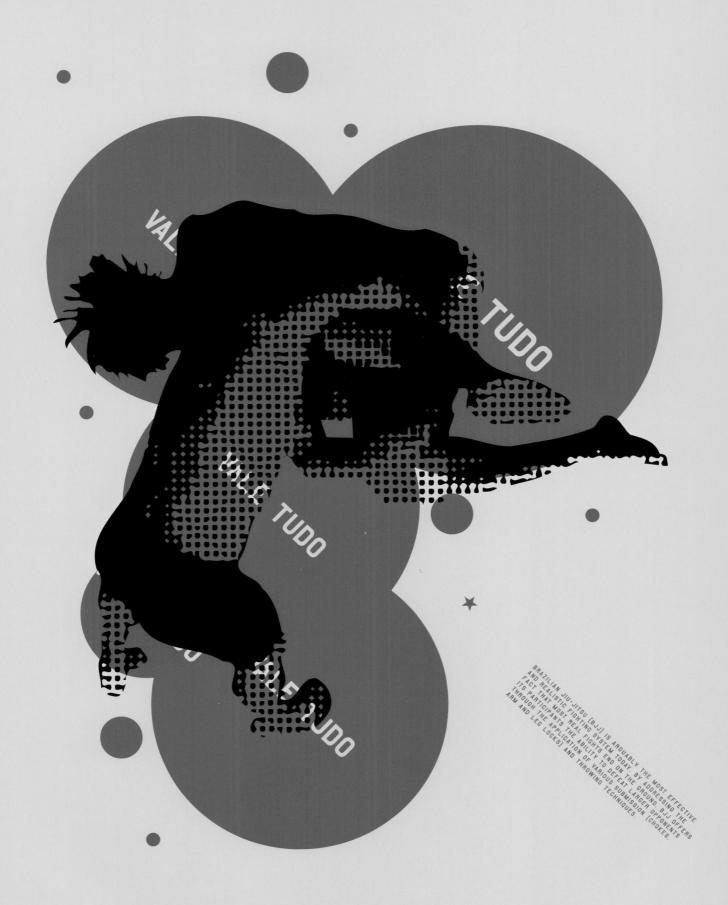

VALE TUDO

TUDO

VALE TUDO

VALE TUDO

BRAZILIAN JIU-JITSU (BJJ) IS ARGUABLY THE MOST EFFECTIVE AND REALISTIC FIGHTING SYSTEM TODAY. BY ADDRESSING THE FACT THAT MOST REAL FIGHTS END ON THE GROUND, BJJ OFFERS ITS PARTICIPANTS THE ABILITY TO DEFEAT LARGER OPPONENTS THROUGH THE APPLICATION OF VARIOUS SUBMISSION (CHOKES, ARM AND LEG LOCKS) AND THROWING TECHNIQUES.

Christ
the Redeemer

This Secret Base is located in Corcovado, Rio de Janeiro. Unbeknownst to millions of tourists the statue houses an underground lair where Brasileiros recharge their special powers.

01

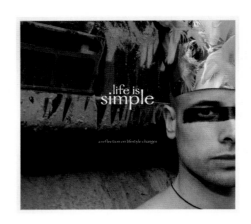

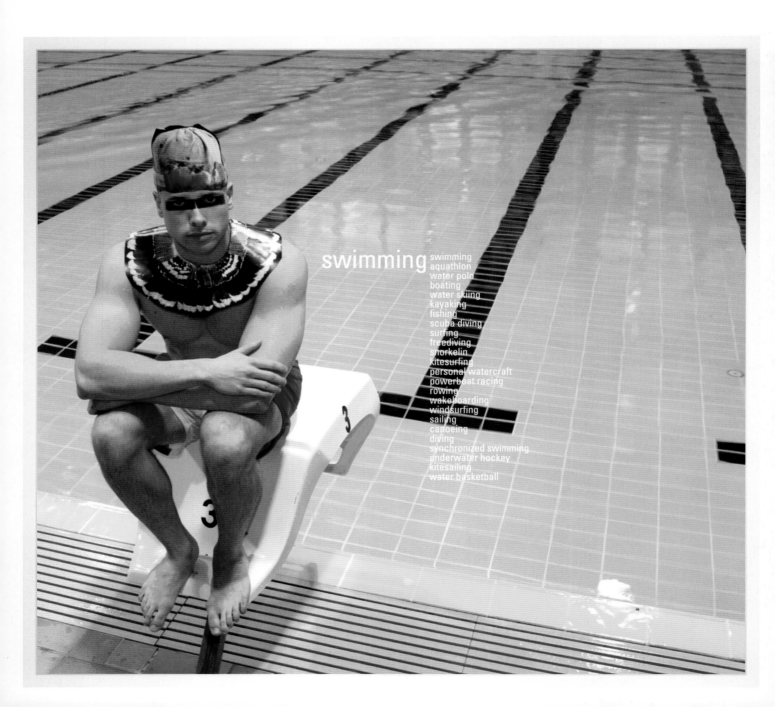

swimming

swimming
aquathlon
water polo
boating
water skiing
kayaking
fishing
scuba diving
surfing
freediving
snorkelin
kitesurfing
personal watercraft
powerboat racing
rowing
wakeboarding
windsurfing
sailing
canoeing
diving
synchronized swimming
underwater hockey
kitesailing
water basketball

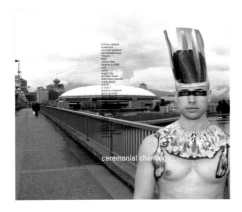

ceremonial chanting

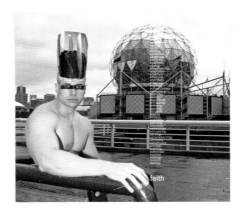

faith

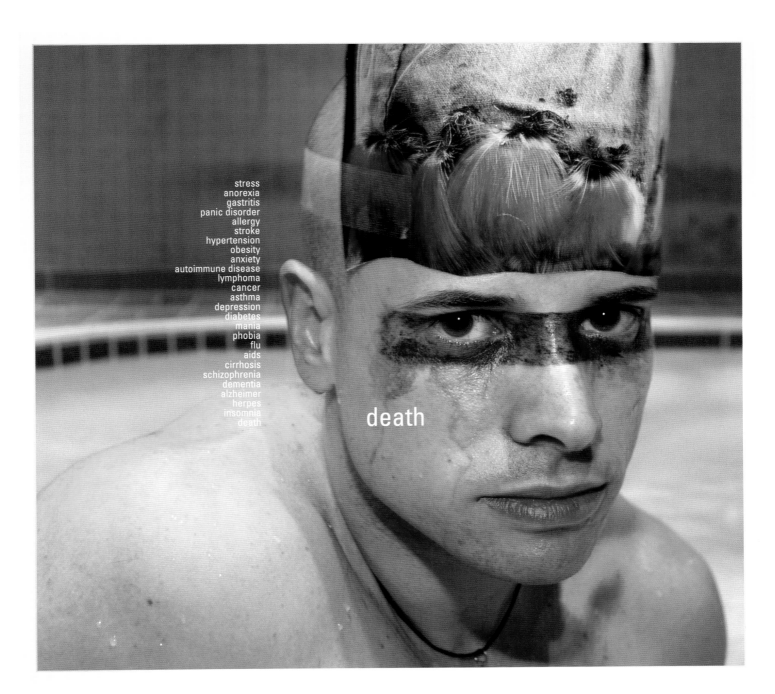

stress
anorexia
gastritis
panic disorder
allergy
stroke
hypertension
obesity
anxiety
autoimmune disease
lymphoma
cancer
asthma
depression
diabetes
mania
phobia
flu
aids
cirrhosis
schizophrenia
dementia
alzheimer
herpes
insomnia
death

death

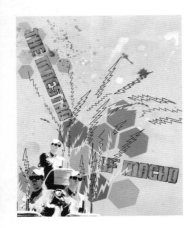

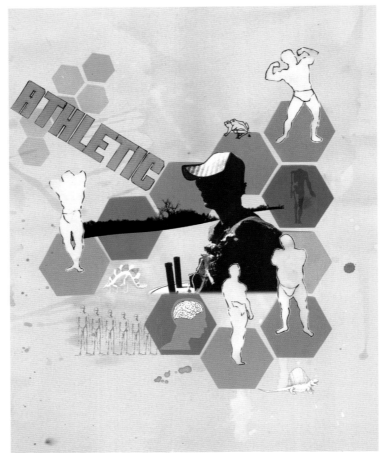

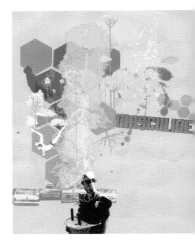

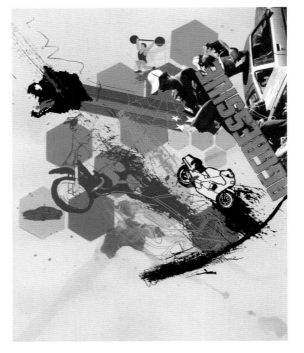

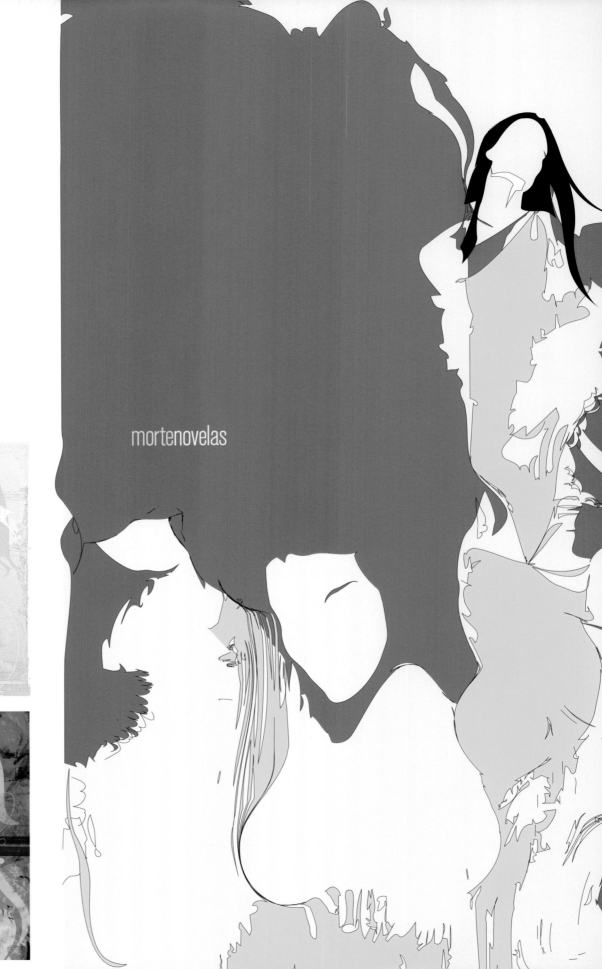

mortenovelas

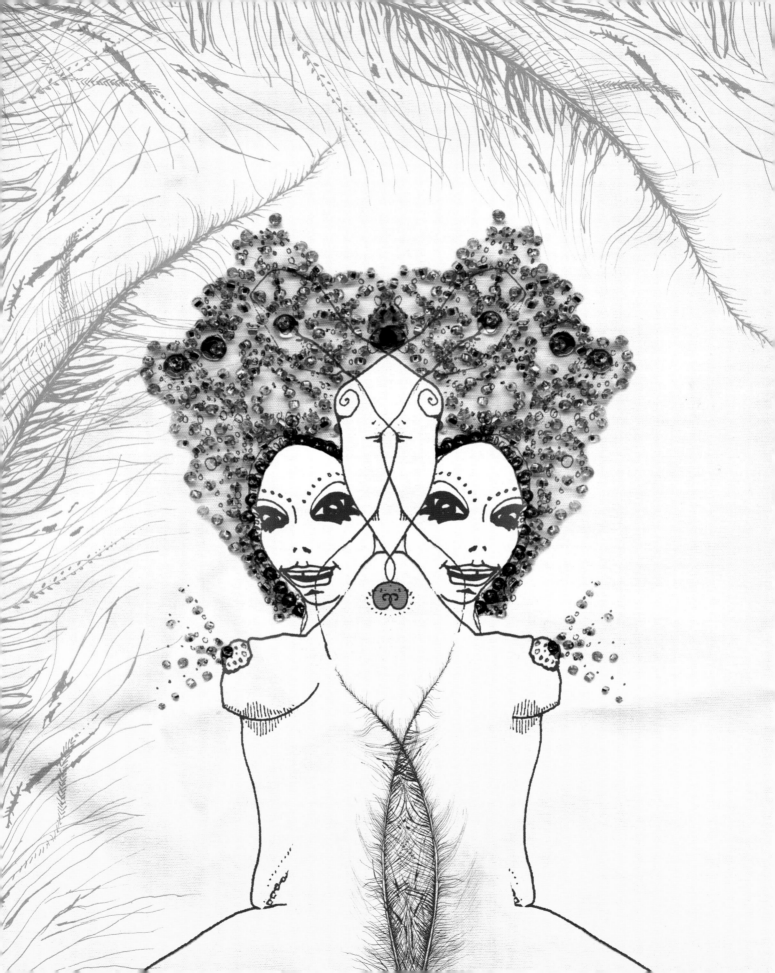

YOU JUST STARTED NAKD IN RIO TOGETHER WITH NANDO. WHAT SORT OF PROJECTS DO YOU DO? IN WHICH WAY DO YOU TEAM UP?

We're primarily a broadcast design studio, but we'll eventually also work with print and web. Nando and I work really well together, and I think our different styles and minds compliment each other. We often mix his vectors with my more ragged drawings. We usually come up with a concept together, but since I don't animate much (yet), I mostly just work on the design and illustration part of a project.

BRAZIL AND SWEDEN BOTH SEEM TO HAVE A PRETTY GENUINE DESIGN SCENE AND A CREATIVE APPROACH THAT'S FAR FROM MAINSTREAM. WHICH ARE OBVIOUS SIMILARITIES OR CONTRADICTIONS THAT NEED A LITTLE LONGER TO REVEAL THEMSELVES?

I don't feel like I know enough about the Brazilian design scene to really compare it to Sweden's. However, my impression so far has been that a generational change is taking place within Brazilian design. The tradition in Sweden is to keep the design very clean and simple whilst in Brazil the design tends to be more decorative. This shows in everything from design to architecture to fashion. In general there's a lot of metallic-looking bevels going on in Brazil, but the new generation is producing a lot of new really cool creative work. I think the economic situation in Brazil really holds back many of the designers. Companies don't have much money to spend so they go for the sure thing, which happens to be the metallic bevels. Swedish and Brazilian design is a bit like the people who live there. In Sweden it's a bit cold and pale and in Brazil it's warm and colorful.

HOW DOES BRAZIL INFLUENCE YOUR WORK / YOUR LIFE? WHAT DO YOU LEARN FROM BRAZIL?

For some reason I've started using a lot more color in my design since I've been in Rio. I think it might be because of all the light and sun I've been exposed to. I've learned a lot, mostly about my values and myself. Brazil is a country, which makes you really appreciate what you have. I've also learned that rules and laws only exist in theory and shouldn't particularly be followed.

WHAT IS YOUR BACKGROUND, WHO DO YOU CONSIDER YOUR PERSONAL INFLUENCES?

I have studied advertising at RMI-Berghs School of Communication, graphic design at various places in England and at the School of the Art Institute of Chicago. People in my surroundings are always a good source of inspiration, especially my husband.

WHICH NON-DESIGN INFLUENCES DO YOU CONSIDER TO BE IMPORTANT (E.G. MUSIC, FINE ARTS, VIDEO GAMES, ETC.)?

I think influences should come from everything that is not design, from nature and people for example.

TELL US A BIT ABOUT YOUR WORK. IS THERE A SPECIAL PREFERENCE, AIM OR PHILOSOPHY?

I wouldn't say my work has a certain aim in general, but I like to reflect on matters that I care for such as beauty, ideals and other odd obsessions that rule our lives.

HOW DO YOU FEEL ABOUT BRAZILIAN CLICHÉS SUCH AS SAMBA, FOOTBALL, BEACH, CARNIVAL, THE AMAZON, POLLUTION, CORRUPTION?

I've lived in Brazil for 6 months now and it still feels like I haven't experienced the place at all. The clichés are there though and they are all true ;-). It is those things, which make Brazil what it is. Football and Samba are being played everywhere. The beach is crowded with people of all ages playing beach volleyball and football and everyone's super fit. It's quite fascinating to see all these well-trained bodies everywhere, but I find it a bit repelling at the same time. Many men but especially women spend half their day at the gym and the other half at the beauty parlor. There's a lot of pressure here to have "the perfect measurements". The corruption is a huge problem and there have been a lot of scandals since I've been here. It's deeply rooted in their culture, and I don't think it will go away as long as 70% of the population lives in poverty.

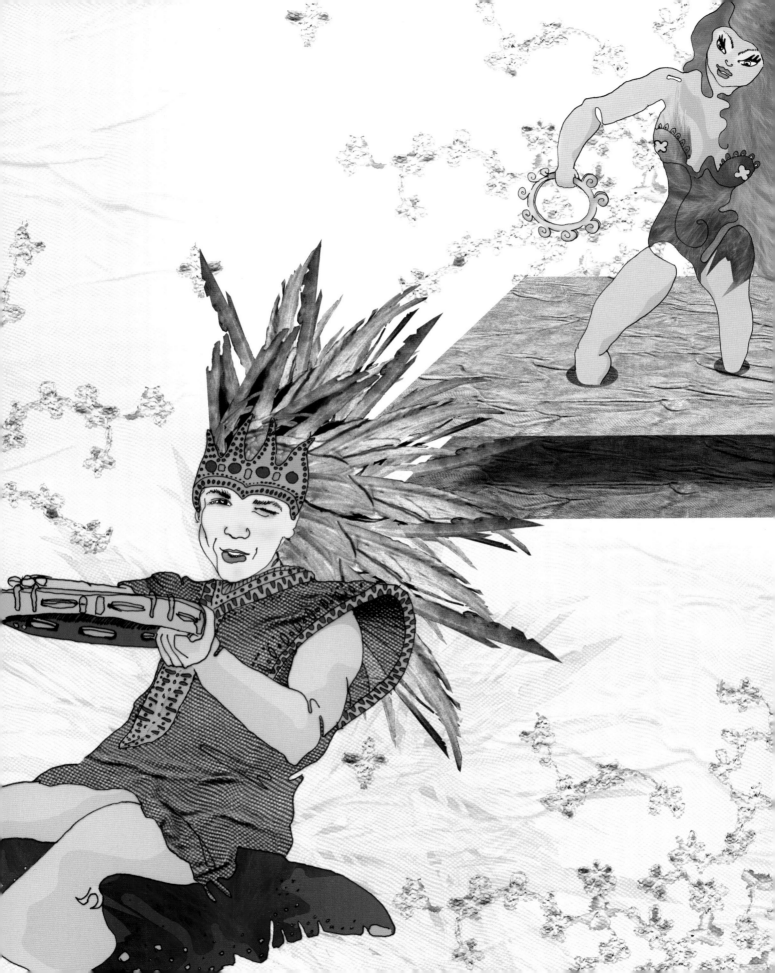

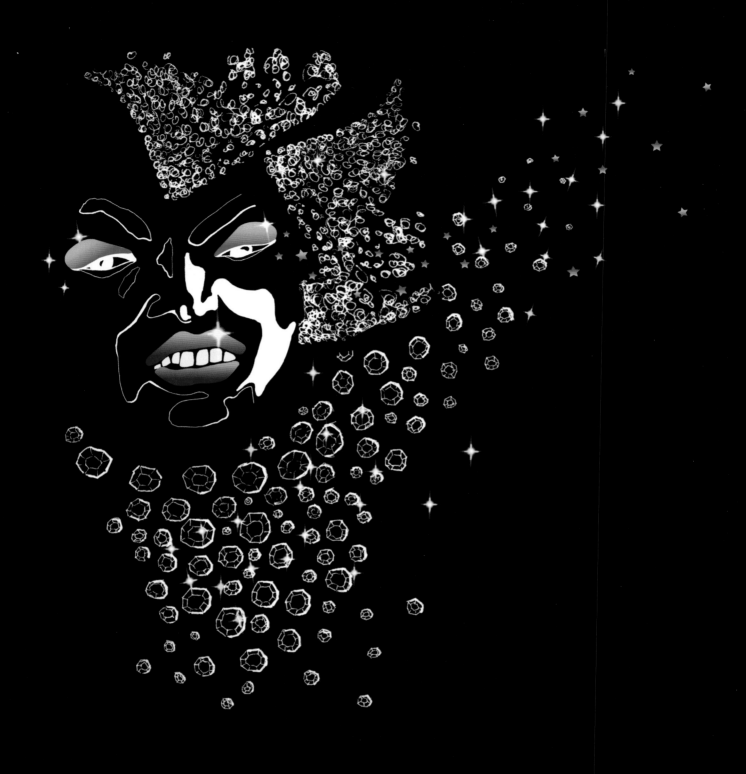

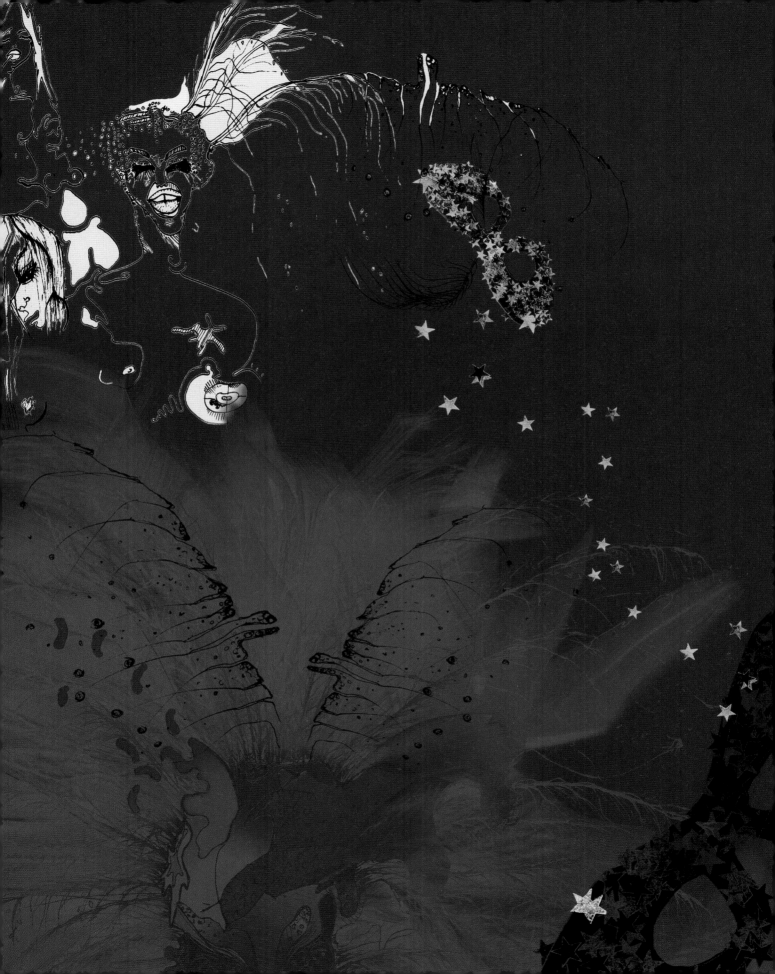

PLEASE DEFINE FÊMUR.

fêmur is Angela Detanico and Rafael Lain.

HOW DOES LIVING IN BRAZIL AFFECT YOUR ARTISTIC DECISIONS AND CREATIVE PROCESS?

Brazil is our background. It is the food we eat, the streets we walk through, the daylight we grow up seeing. All of this is embedded in our work. So it is an important part of it, although we do not pursue any national identity in design. If our work looks like a Brazilian production, it is more a consequence than a cause. We see being Brazilians as a fact that leads our approach to design as well as any other aspect of our lives.

HOW IS THE NEW WAVE OF ARTISTS AND DESIGNERS CREATING A NEW ARTISTIC VISION OF BRAZIL? WHICH ARE YOUR BRAZILIAN INFLUENCES AND WHICH ONES COME FROM OVERSEAS?

Each new generation translates its view of reality into cultural products according to the moment people are living. Our generation experienced important historic transitions, both national and international. It is the one that saw the military dictatorship fade away, and the world opening itself for a globalized age. So it may want to revitalize culture in the framework of a free country and also open up to the external influences that come naturally in a shrinking world.

WHICH TOOLS DEFINE YOUR STYLE? THE ANALOG OR DIGITAL ONES?

Our work is not based on any specific tool. We can use a pencil or a laptop. We switch from analog to digital depending on what is around and what we want as a final result for an idea. Tools are means to reach results. If you want a hole in the wall, you can use a nail or a drill. Depending on the kind of hole you want, you take the one or the other.

HOW IMPORTANT ARE SEMIOTICS AND THE WRITTEN WORD AS AN ICON IN FÊMUR'S CREATIVE PROCESS?

Written words are the encounter of two languages, verbal and visual. In this sense, they stand as a symbol of our personal trajectories that include academic research in language and semiotics in addition to graphic production. That may be the reason why we feel so attracted to developing typefaces. They are the very point where these two fields of interest melt.

FÊMUR HAS BEEN DEVELOPING ITS CREATIVE PROCESS IN THE PALAIS DE TOKYO IN PARIS, FRANCE. HOW DID THAT DIRECTLY AFFECT FÊMUR AND DID YOU FIND ANY IMPORTANT DIFFERENCES BETWEEN WORKING THERE AND WORKING IN BRAZIL?

We position ourselves not in the center, but on the border of the graphic design world. We are very interested in different ways of producing visual material. Working inside an art institution such as the Palais de Tokyo gave us the opportunity to develop projects that for different reasons could not be carried out within the graphic design action field. This experience, as any other significant one, opened new challenges and possibilities for our work. Which does not mean that we abandoned our graphic design approach and techniques. A significant part of our actual work is strongly rooted in our design background, whether it is published in a graphic design compilation or exhibited in an art show. In the end, we don't really care about it as long as we are able to develop our ideas. About the differences between working in France and in Brazil, the most remarkable may be the fact that we were invited to work within an art institution framework. We are not sure if that would happen in Brazil, but we can't tell since we haven't tried.

BRAZIL HAS AN IMPORTANT ART, CULTURAL AND DESIGN SCENE THAT ESPECIALLY DEVELOPED IN THE 60'S. WHY DO YOU THINK THAT IT TOOK UNTIL NOW FOR THERE TO BE A REAL NEW BREED OF DESIGNERS? IN TERMS OF BEING KNOWN OVERSEAS AS WELL, IS IT A DIRECT RESULT OF THE OVERSEAS INTEREST OR THE BRAZILIAN?

In our opinion many factors provided a fertile terrain for a new breed of Brazilian designers: the circulation of graphic design objects such as books, magazines and web sites was a breath of fresh, inspiring air; the development of hard and software made it easier to produce and distribute design products such as typefaces; the emergence of new clients such as cable television channels and the increased number of others such as music labels and magazines; and, finally, the growing attention graphic design has being receiving as a field of contemporary culture production. Even in different proportions, all these factors seem related to the globalization process. And we know that globalization has the side effect of raising interest in local cultures. So on the other hand of the global culture, there is an effort to pack national products in a local involucrum, in order to make them more attractive and understandable for the international market. It may help to show the world what different cultures and generations are producing, but in the end you can have music, art, fashion, etc. that are much too local, reaching a cliché level in an artificial effort to have a common identity.

BRAZIL IS ALWAYS KNOWN BECAUSE OF BASIC CLICHÉS SUCH AS FOOTBALL, SAMBA, CARNIVAL, BOSSANOVA AND THE FAVELAS. BUT IN YOUR OPINION WHICH IMPORTANT FACTS SHOULD ALSO BE KNOWN WHEN WE SPEAK ABOUT BRAZIL?

We wish to point out that Brazil's clichés are not restricted to the ones you mentioned, and avoiding them can prove to be not an easy task. If we want to produce graphic design that reflects contemporary Brazilian culture, we may keep in perspective the complexities of a huge country that mixed different cultural backgrounds through colonization, slavery and immigration processes, in which some people take part if the global community by traveling and surfing the web while others remain in illiteracy, and where technology is accessible to a few while most live under the line of poverty. Ignoring any of the facets of a country that stands as one of the most important global economies while at the same time serving as an anti-model when it comes to the distribution of wealth seems to us to be a risky approach.

WHAT'S NEXT FOR FÊMUR?

Tomorrow.

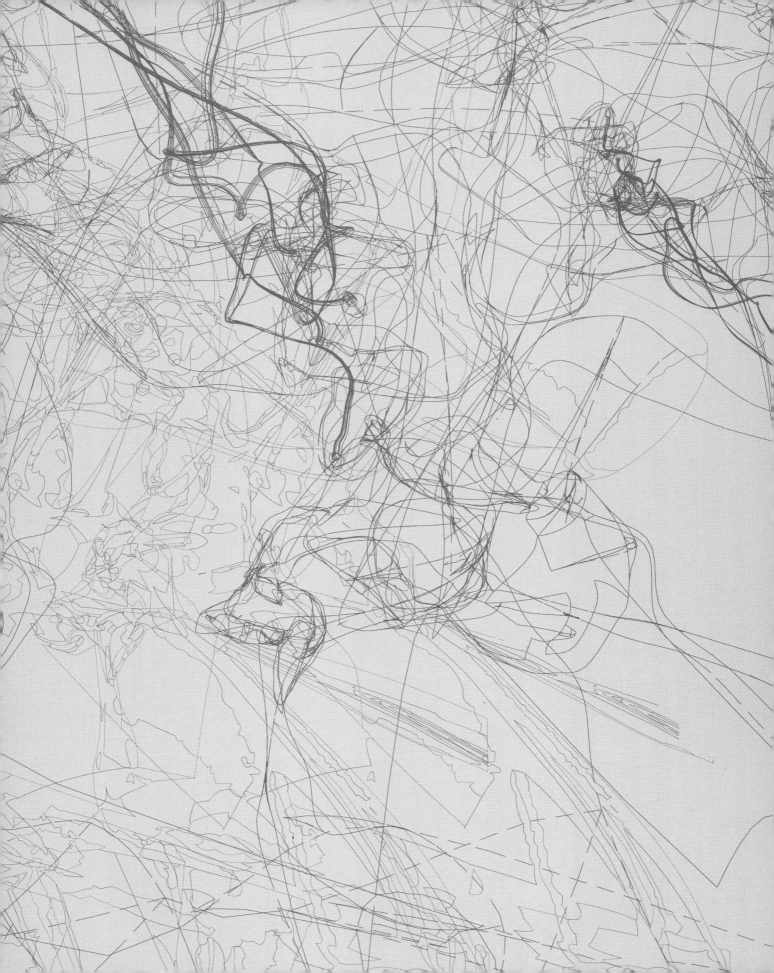

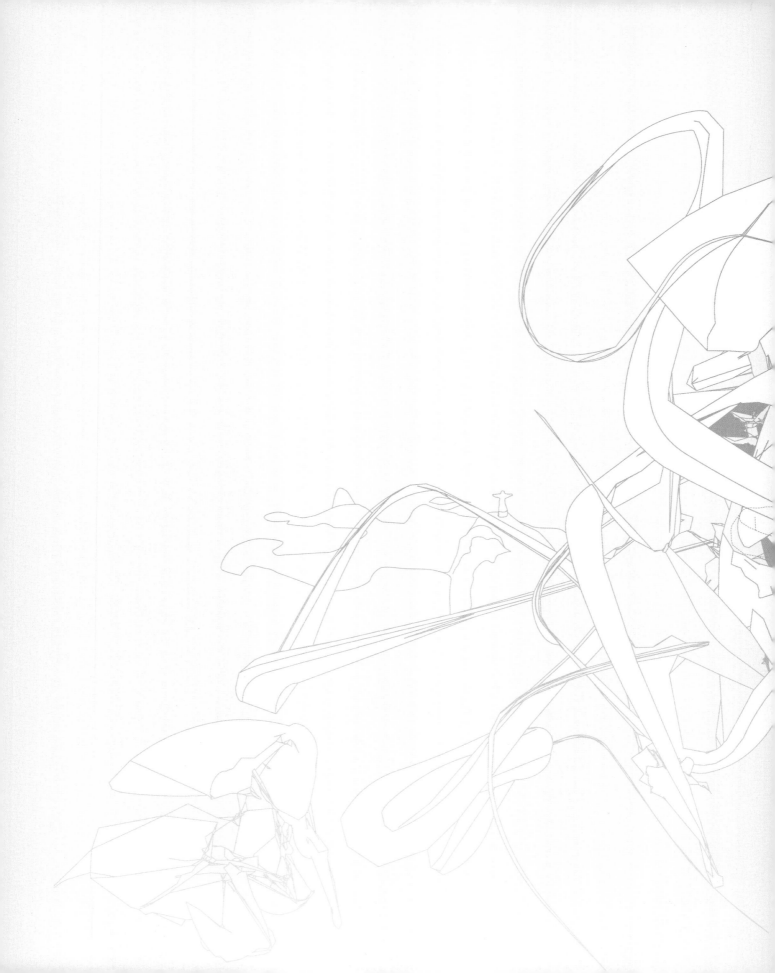

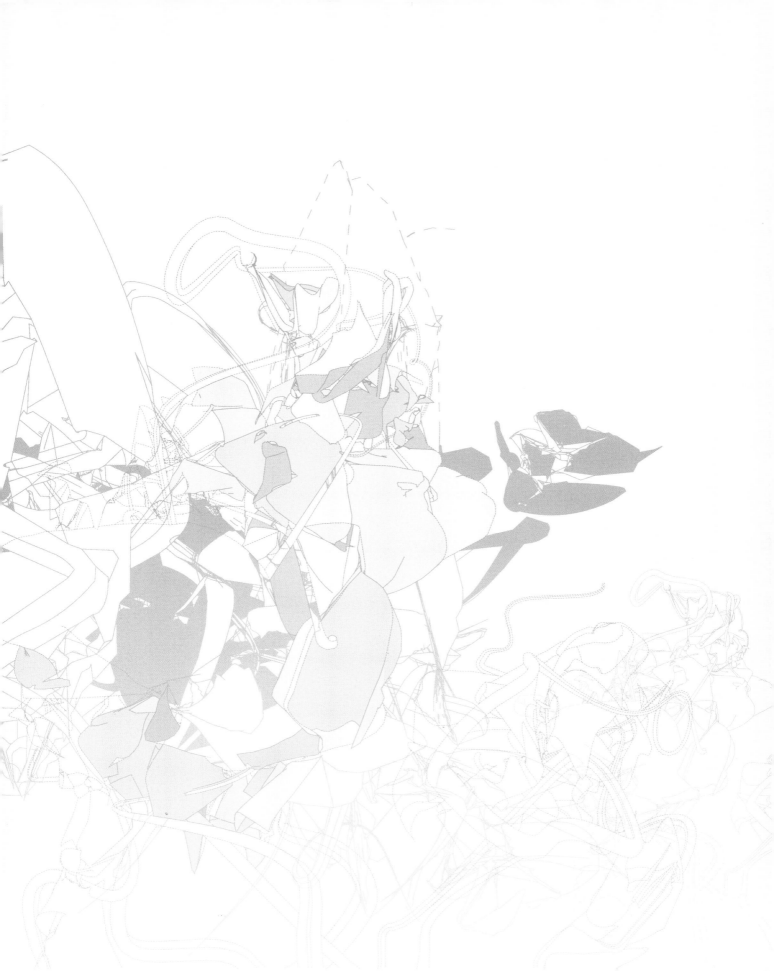

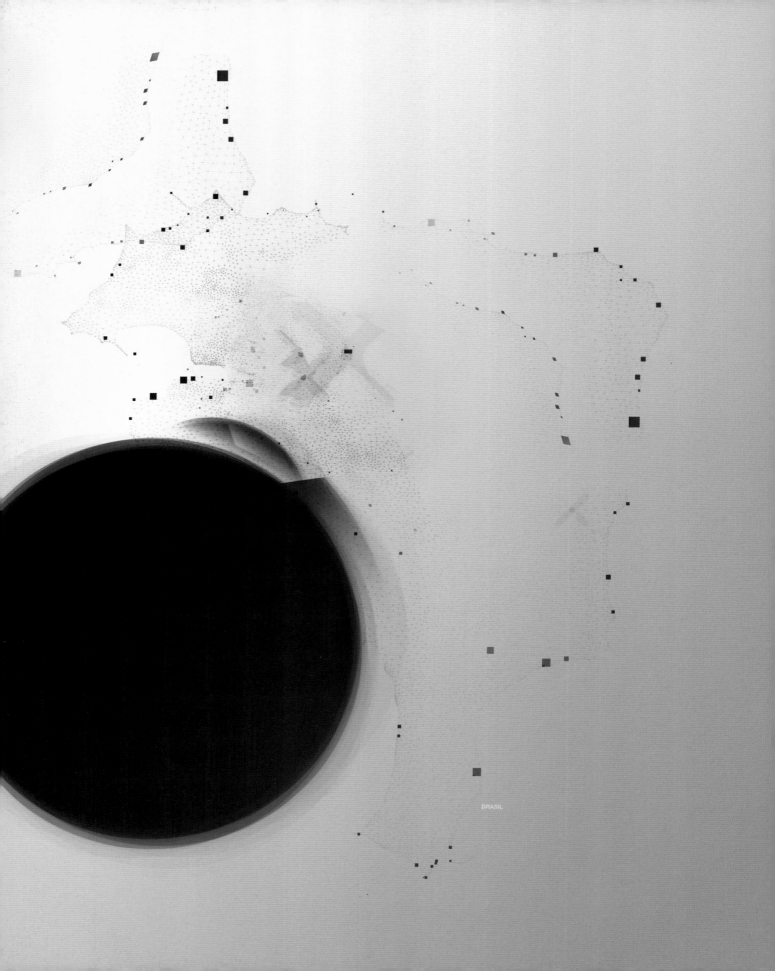

BRASIL

NOSTALGIA

COMO EU FAÇO PRA CHEGAR NA RUA TATUÍ?

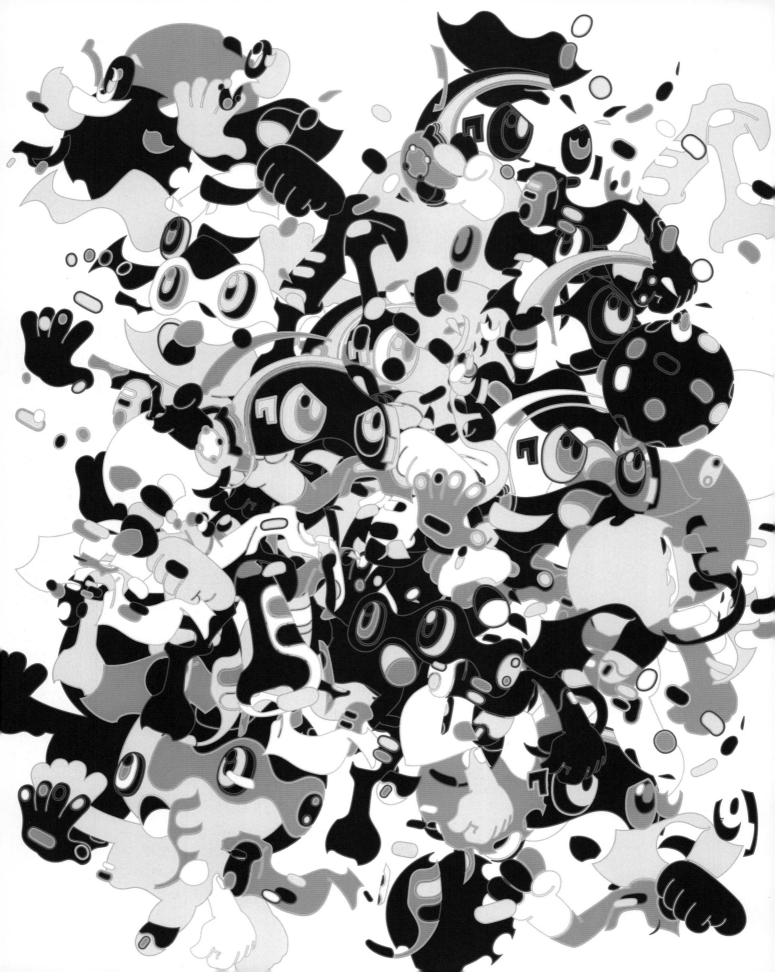

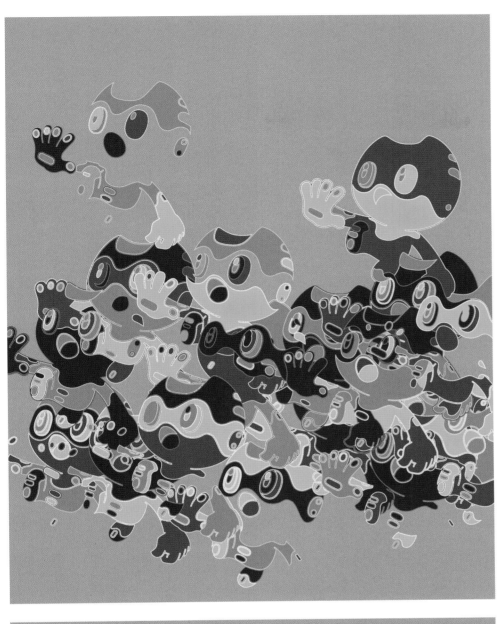

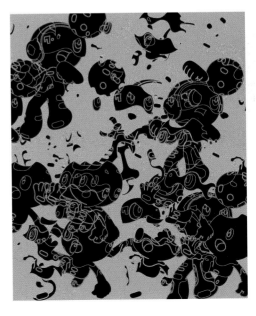

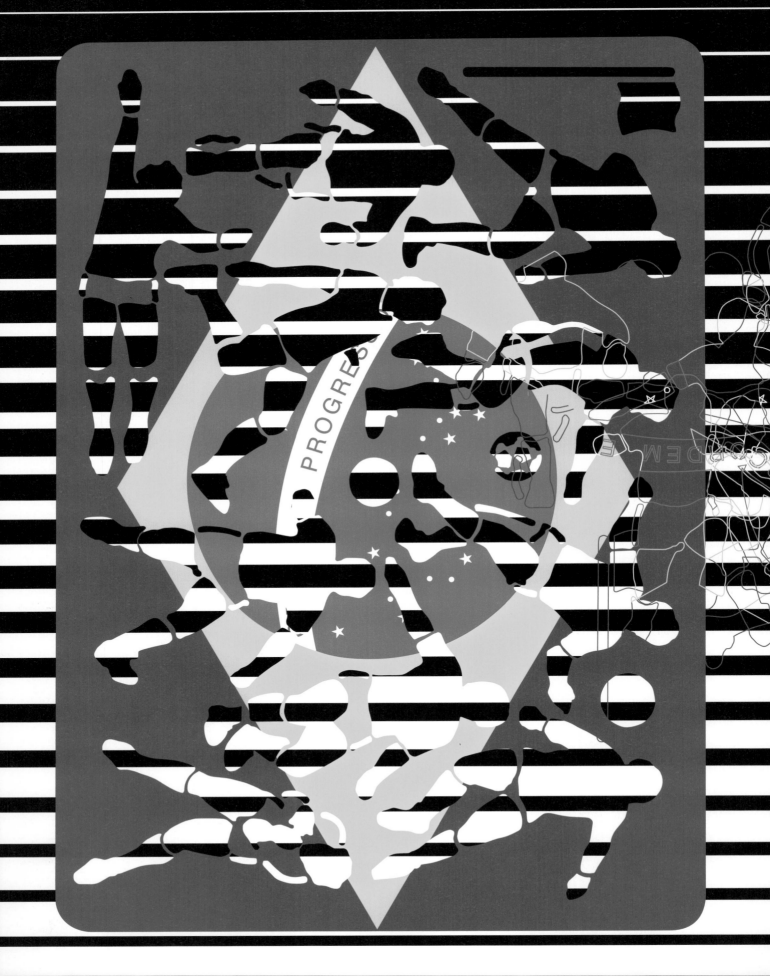

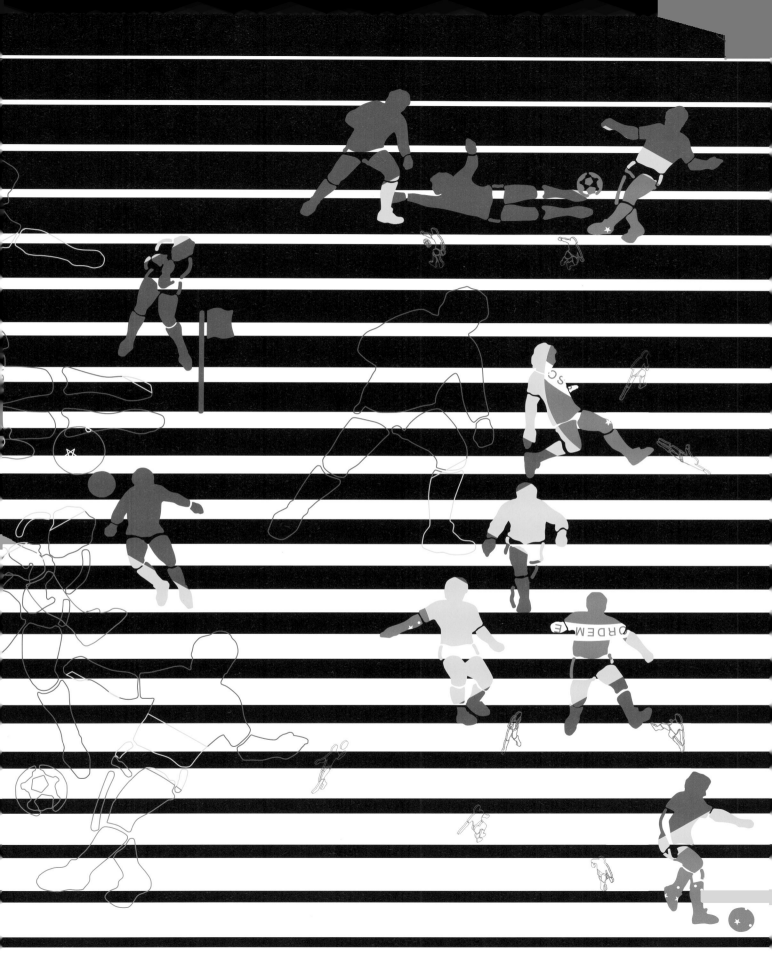

ps . (3) + brazil topography and flag reconstruction + ver . 01

ps . (3) + brazil topography and flag reconstruction + ver . 03

PLEASE TELL US A BIT ABOUT LOBO. WHAT ARE YOUR MAIN FIELDS OF ACTIVITY?
Lobo is a design and animation studio based in São Paulo, Brazil. Our main activities include broadcast design, clay and cell animation and design services in general. The Ebeling Group represents us internationally.

"SCIENTIA SACRA LUPI" IS A VIDEO SERIES ABOUT BRAZILIAN MYTHS. AS BRAZILIAN CULTURE IS BASED ON A PATCHWORK OF ALL ITS DIVERSE CULTURAL ROOTS, WHERE DO BRAZILIAN MYTHS HAVE THEIR MAIN ORIGIN?
All over the place. There's no specific place to research; some myths are quite new, others are ancient. In our opinion it's a mix of religion and popular science.

WHICH BRAZILIAN TRADITIONS, TECHNIQUES AND STRUCTURES DO YOU CONSIDER IMPORTANT TO CREATING A UNIQUE DESIGN SCHOOL?
I don't believe in a Brazilian design school. Not that we don't have our identity, but design is not art. It's for clients and for fun, and most of our clients are not interested in the Amazon or in Capoeira. Of course being from Brazil, growing up in Brazil and so forth gives us our own perspective, but that's as far as talking about identity goes.

ASIA HAS BECOME ENORMOUSLY IMPORTANT IN VISUAL CULTURE BECAUSE OF ITS GAMING INDUSTRY, CHARACTER DESIGN, MANGA, ETC. SOUTH AMERICA'S CREATIVE INDUSTRY IS THE FASTEST GROWING AT THE MOMENT. WHAT ARE THE MAIN INFLUENCES THAT YOU EXPECT TO COME FROM THERE?
We're just more relaxed, not as uptight as Americans or Asians. That might seem a bit of a prejudice or a cliché, but I believe that it's true and may in the future change the way business and design are handled worldwide. Or maybe not.

AS A COUNTRY, BRAZIL IS VERY DIVERSE. IN ITALY YOU HAVE A NORTHERN PART, WHICH IS WELL ORGANIZED AND INDUSTRIAL WHILE THE SOUTH STANDS MORE FOR AN ITALIAN SENSIBILITY. DOES SOMETHING LIKE THIS EXIST IN BRAZIL? WHAT ARE THE ROLES OF RIO AND SÃO PAULO?
This is also very true in Brazil. The north is poor; the south is richer but also poor. About São Paulo and Rio, there's a lot coming from both cities, and a lot of rivalry but it's all bullshit. Brazil is such a baby in terms of design that there's room for everybody.

LATIN AMERICAN COUNTRIES ARE VERY MUCH INFLUENCED BY, NOT TO SAY DEPENDANT ON AMERICA. COMPARATIVELY, BRAZIL SEEMS TO ADOPT THE AMERICAN WAY OF LIFE MUCH LESS THAN OTHER COUNTRIES. WHAT IS THE REASON FOR THIS?
I don't agree. We're as influenced by the American Way of Life as any other country in South America. In my opinion America is responsible for a big part of the happiness and sadness in the world. The influence is huge in all parts of society. And we also depend on them. Sad, but true – especially these days.

HUMOR AND LIGHTNESS SEEMS TO BE A STRONG ELEMENT. BRAZILIANS SHOW A LOT OF CREATIVITY FINDING WAYS TO MAKE A LIVING. CARNIVAL COSTUMES ARE JUST ONE EXAMPLE OF THE PEOPLE'S IMAGINATION AND CREATIVITY. BRAZILIAN COMMERCIALS HAVE WON MANY AWARDS FOR THEIR WIT AND ORIGINALITY. DO YOU SEE A CONNECTION? WOULD YOU CONSIDER IT COMPLICATED FOR A TALENT COMING FROM A MODEST BACKGROUND TO BREAK INTO THIS "CREATIVE ELITE"?
I think we're good at handling difficult situations. There is probably a connection, but again, there's a lot of demagogy about it. I don't really feel comfortable talking about "Brazilian Culture." Our piece for the book was just a naive interpretation of myths, designers making a not very deep comment about Brazilian culture. We try hard not to be pretentious.

HOW DO YOU RATE THE POSSIBILITY OF USING YOUR CREATIVE BACKGROUND TO SPEAK OUT ON SOCIAL OR POLITICAL THEMES?
There's always the risk of being naive or shallow. That's not a reason not to try. Image is powerful; it can obviously change the world or at least reflect what's going on.
Everything we do is political; it's just that most times we're not aware of it.

FIG. 01

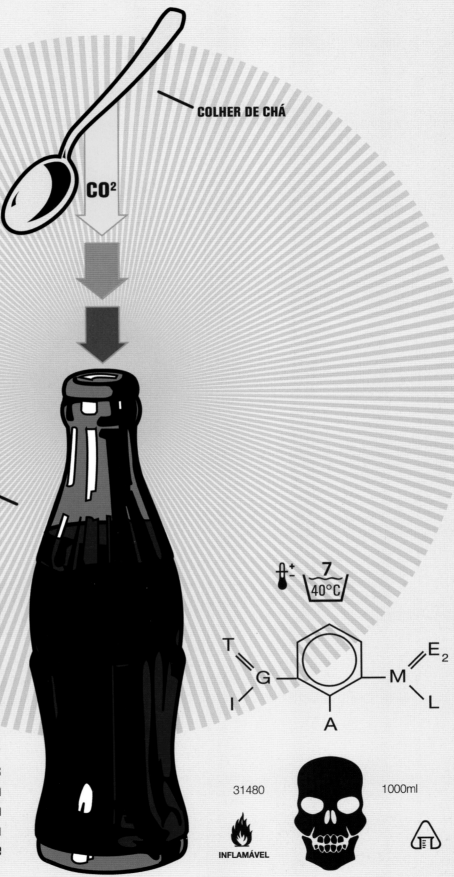

COLHER DE CHÁ

CO²

GARRAFA DE
REFRIGERANTE

**Processo do Vasamento de
Gás (CO2) de Uma Garrafa
de Refrigerante**

• o gás de uma garrafa de refri-
gerante deixada aberta dentro
da geladeira (ou mesmo fora)
escapa pelo fato de Co2 ser
menos denso que o ar.

• com a inserção de uma simples
colher das de chá metálica (nun
ca das de plástico) voltada com
a concha para cima, o gás pára
de sair instantaneamente

7
40°C

T ≡ G E₂ = M L

A

31480 1000ml

INFLAMÁVEL

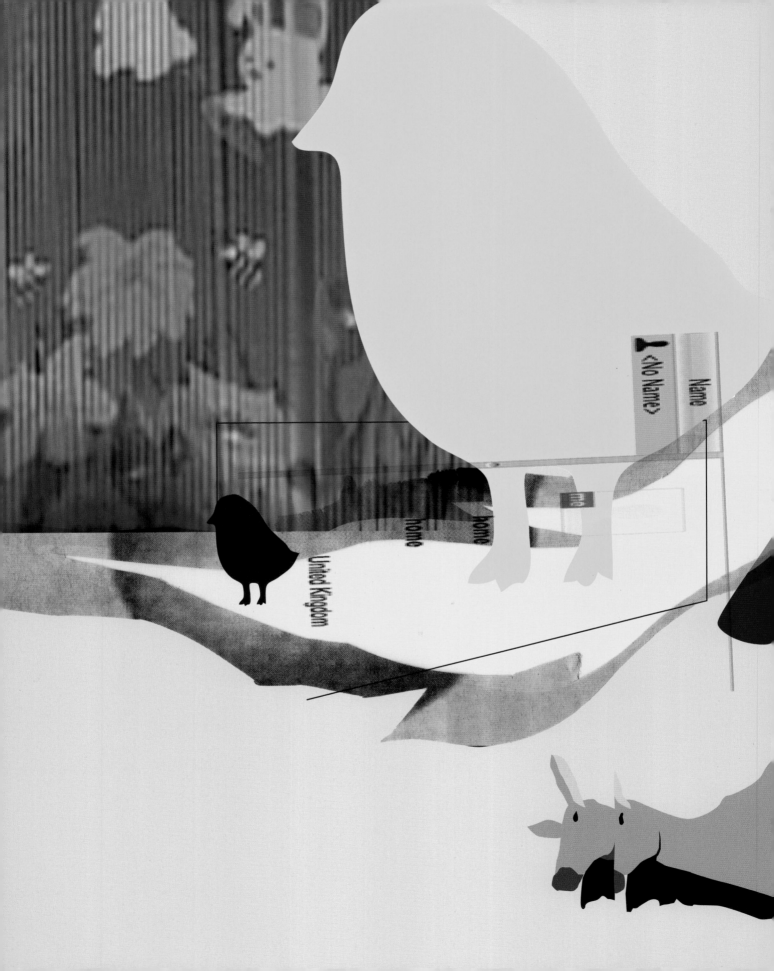

que
preto, que índio o
branco, que branco, que
quê?... que preto, que branco, que quê?
índio que preto, branco, índio o quê? índio preto
que índio, que preto, branco, índio o quê? índio preto
o quê?... que preto branco o quê?... índio mestiços
branco o quê?... Aqui somos mameLucos sararás
mulatos cafuZos Paranisseis e juPárabes
crioulos orientupis americuStalos luso nipo
caboclos orientupis iberiBárbaros indo
orientupis orientupis inclassificáveis tem
cisanaçôs somos o que somos não tem Pois, tem
não tem um lei Deus, leis, não tem Deuses, não há
três, não tem vezes, não tem Deus, tem mestiços mulatos
tem vezes, Aqui somos tupinamBoclos somos o que
sol a sós parZos tapuias yoruBárbaros que preto, que branco,
cafuZos caratags inclassificáveis que índio que quê?
americaratags inclassificáveis que índio preto que um
somos inclassificáveis que índio preto não tem tem
branco, que índio índio preto três, tem Pois,
que índio índio preto que o quê três tem Lei, tem
branco que não tem vezes, tem Deus,
preto, Pois, não vetem leis, Deuses, tem
três, não tem Deus, cor,
vezes, não tem não há sol
Deuses, cores espicisanos
tem a sós tupinamBoclos caratags
yoruBárbaros caribocarijós
caribocarijós
orientapuias
mamemulatos
tropicaburés
cavibarrosados
mesticisenados
oxisenados
debaixo do
sol

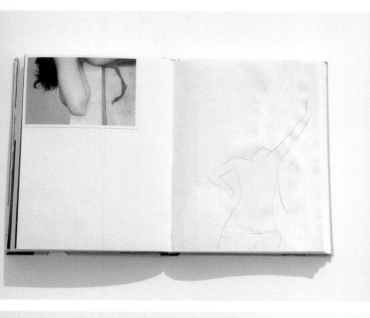
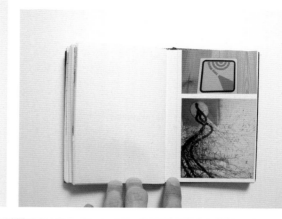
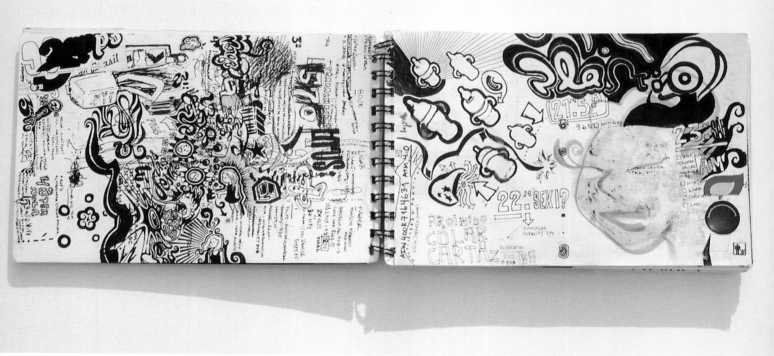

HOW DOES LIVING IN BRAZIL AFFECT YOUR ARTISTIC DECISIONS AND CREATIVE PROCESS?

By living here I learned that creativity can be understood as a game that is made under the unquestionable and precise notion of the existence of limits. We live in an economic situation that will continue to be unstable as long as the country's history keeps making us reappraise plans often and submit to new sets of conditions endlessly and, for the bad part, sometimes silently. Maybe this approach to accepting new rules and overcoming difficult situations is what we call "ginga". The reflection on my work is that I have to adopt many different attitudes to new problems. No preconceptions allowed, just sincere encounters.

THERE'S A WELL-KNOWN AND MARKED DIFFERENCE IN RHYTHM BETWEEN LIVING IN RIO AND SÃO PAULO. HOW DOES IT INFLUENCE YOU?

In Rio de Janeiro you are allowed to listen to your own voice more clearly, which does not mean people will listen too. It's just that the frenzied, market-driven paranoia lives in São Paulo. In SP you have far better structure and money-flow to develop anything. I mean investors and good clients, which means well-paid jobs and professionals working for you. It's the province against the metropolis with all the goods and bads. I am from RJ, but I have lived in SP for the last two years. My city is amazing to live in and very inspirational, but on the professional side it is some light years away from SP.

HOW IS THE NEW WAVE OF ARTISTS AND DESIGNERS CREATING A NEW ARTISTIC VISION OF BRAZIL? WHICH ARE YOUR BRAZILIAN INFLUENCES AND WHICH ONES ARE FROM OVERSEAS?

I am not very sure if it's because of a new breed of artists or because the whole world is communicating and sharing experiences faster. We have a lot of good artists in many different areas, but the boom came in the mid-90's when the world "re-discovered" Brazil. It's clear when you look at the music of the 60's and 70's with Jorge Benjor, Tim Maia, Moacir Santos, Eumir Deodato, the visual arts of Hélio Oiticica, Lygia Clark and Mira Schendel, among others. There's a powerful body of work but weak distribution until now. In graphic design there was the one of a kind Aloísio Magalhães, who was involved in many personal projects along with the commercial ones and was published in Herbert Spencer's Typographica magazine at the time. Also, the very personal modernism interpretation of Oscar Niemeyer, Lúcio Costa and Eduardo Reidy in architecture. My influences come mainly from areas that are not graphic design and the people I referred to above. It's a daily dialogue.

WHICH TOOLS DEFINE YOUR STYLE? THE ANALOG OR DIGITAL ONES?

I like to build my own tools as I flow between media along a path of thought. Technology doesn't mean, it is means. Even when commented.

HOW IMPORTANT IS SKETCHING IN YOUR DAILY CREATIVE PROCESS? HOW DOES BRAZILIAN STREET CULTURE INFLUENCE YOU?

There is a permanent flow between thinking and practice, sketching and the final project, idea and realization. In the end, commercial and personal works begin to blur their boundaries during the process. That's the most interesting part. Sketchbooks are primarily where I register ideas or thoughts, as a friend once said "a toll of tought" – the first physical test of something that exists only in my mind. But not only as a place to sketch a bigger picture, sometimes they are the work itself. In a larger perspective they are always a work by themselves. About the street culture, I was always drawn by non-conventional approaches to making things. The precarious, unstable, being surprised constantly by the freshness or oddity of what is called lower culture. A certain level of improvisation is required to deal with that and this is the very basis of our national procedures.

BRAZIL IS ALWAYS KNOWN BECAUSE OF BASIC CLICHÉS SUCH AS FOOTBALL, SAMBA, CARNIVAL, BOSSANOVA AND THE FAVELAS. BUT IN YOUR OPINION WHICH IMPORTANT FACTS SHOULD ALSO BE KNOWN WHEN WE SPEAK ABOUT BRAZIL?

Brazil should be seen as a place where a new view of the world is emerging.

MUSIC IS A MAJOR CREATIVE FORCE IN BRAZIL. HOW DOES IT GET ALONG WITH YOUR TASTES AND IN WHICH WAY DO YOU MIX IT WITH YOUR DESIGN STYLE?

Music is a spontaneous and self-motivated work. I believe the same applies to my approach to graphic design, although it exists on a narrower context of commercial and practical constraints. We have a strong expression on the music scene and this informs many other areas in different levels. I'd rather work for things that I believe or feel motivated by. Definitely music is one of them. From the musical styles of Jongo to Samba, Brazilian soul to hip-hop, popular music to hardcore, there's a wide spectrum of possibilities.

HOW WOULD YOU DEFINE THE EUROPEAN AND OVERSEAS INFLUENCES (GERMAN, ITALIAN AND JAPANESE) IN THE BRAZILIAN DESIGN CONTEXT?

As a colony, the formation of our country is based mainly on European culture. This forces us to adapt their views of the world to our reality. The problem is that we don't always have the confidence to develop our work as we somehow wait for a foreign approval. This is beginning to change as self-confidence is being reinforced through international recognition.

DEFINE BANDIT
MPC.

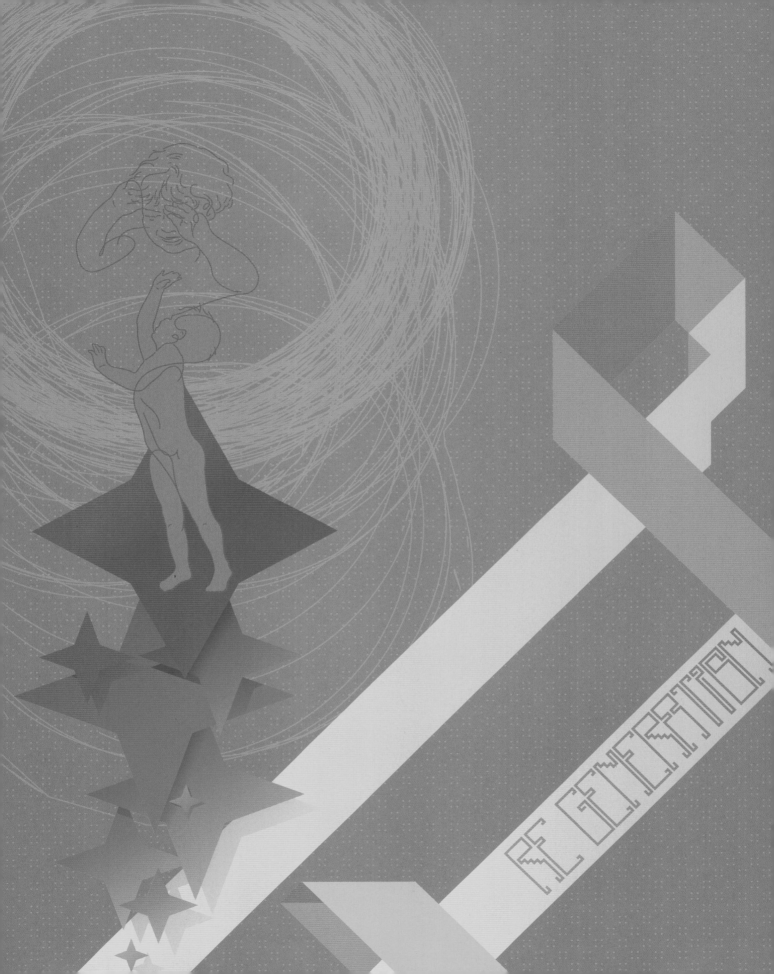

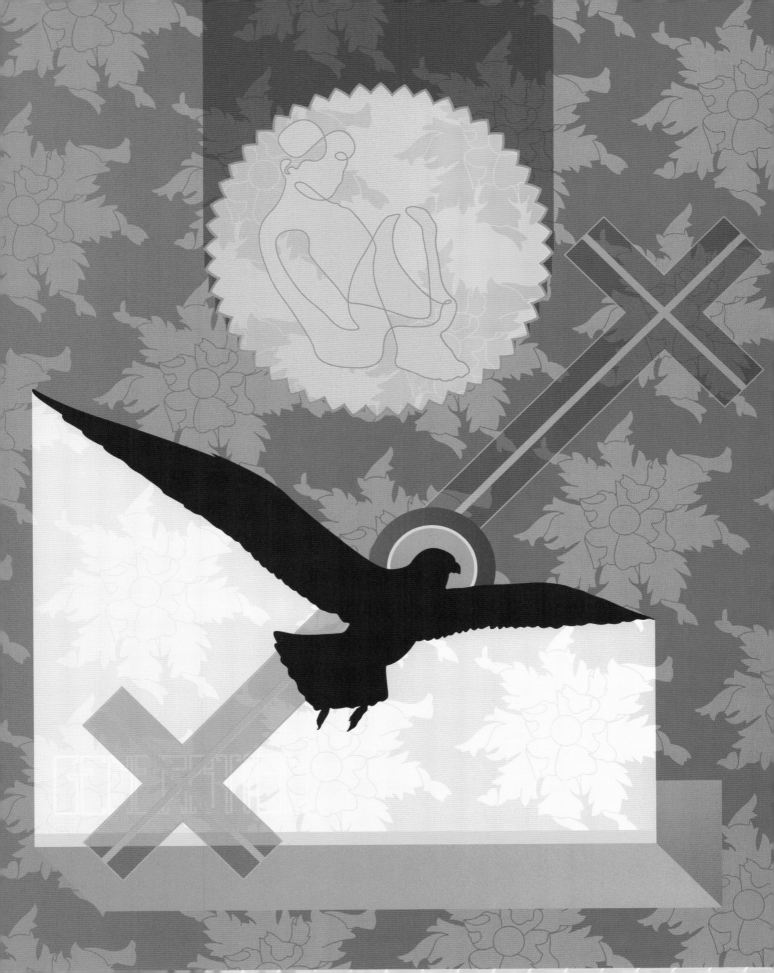

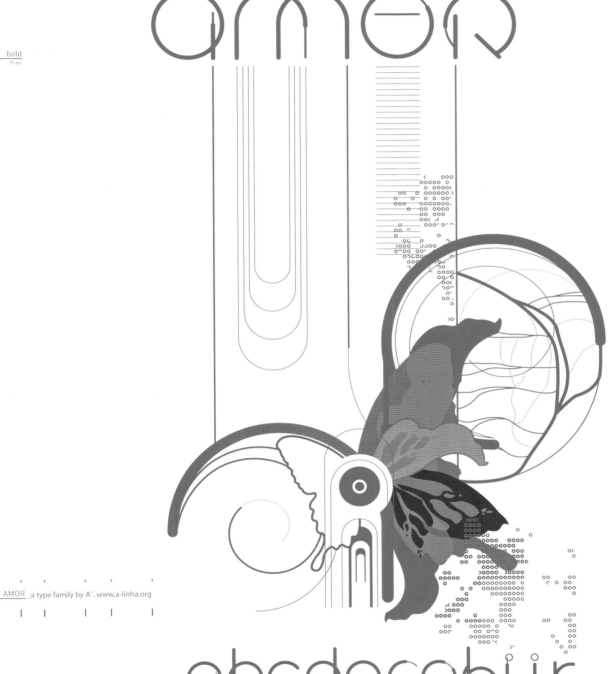

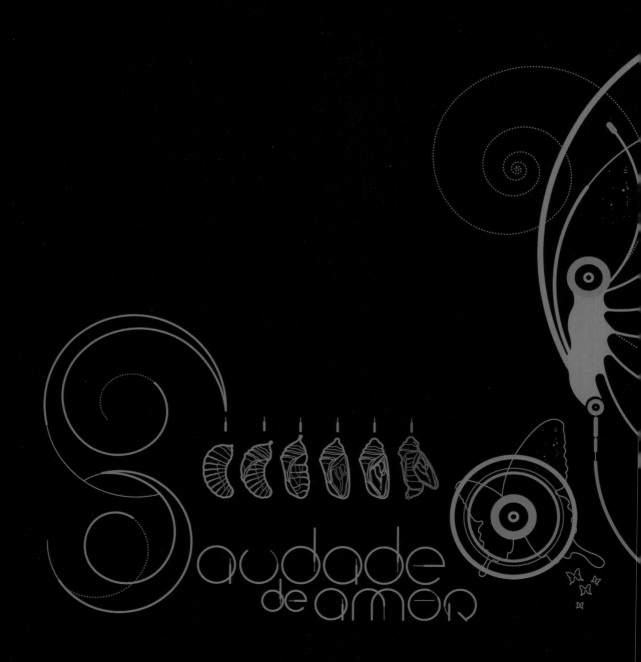

Saudade
de amor

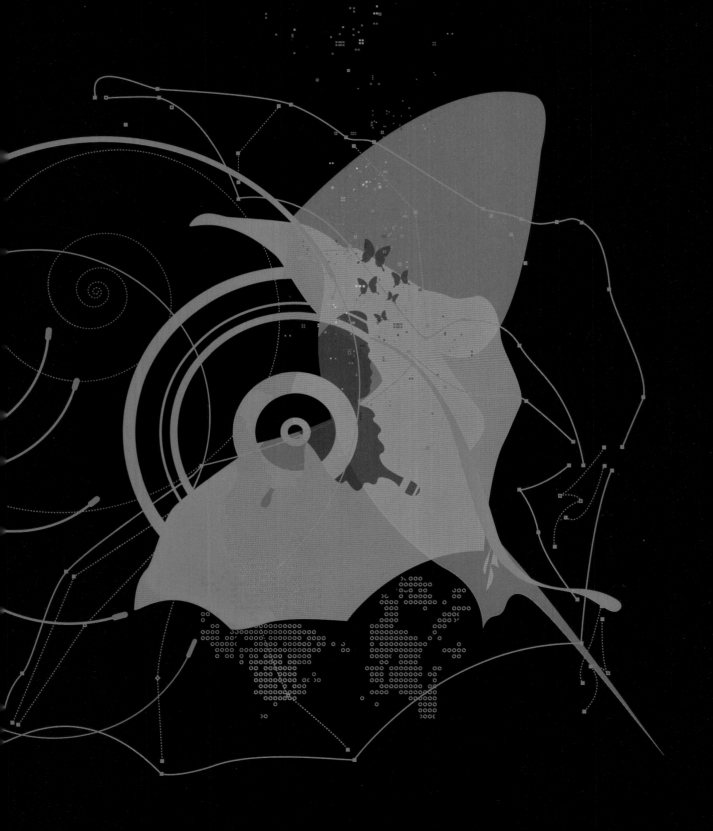

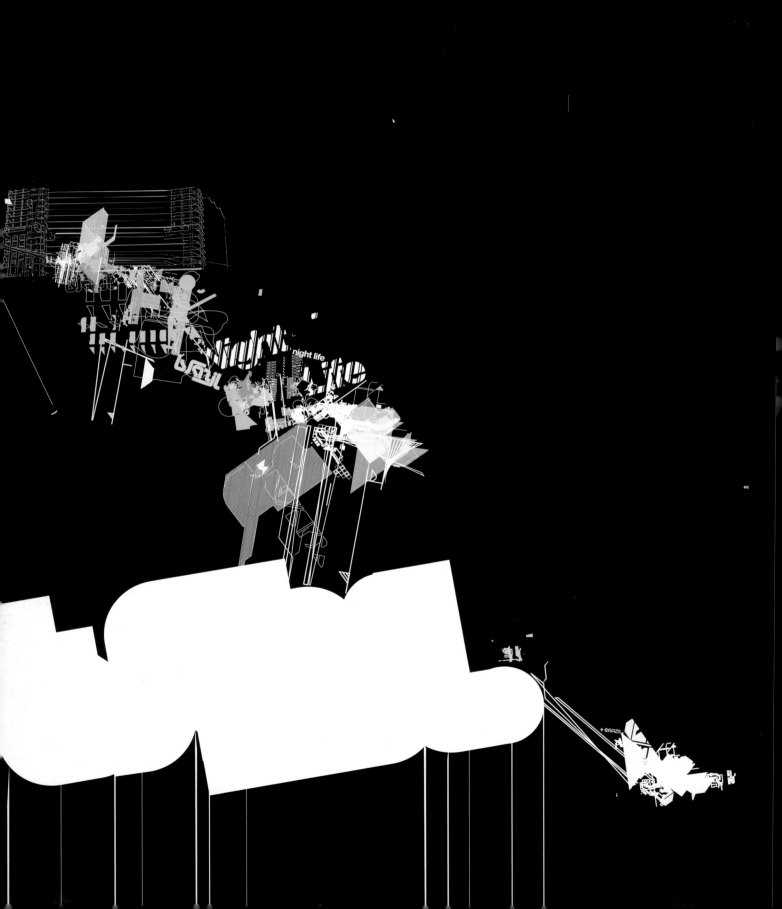

night life

night life

+ BRAZIL

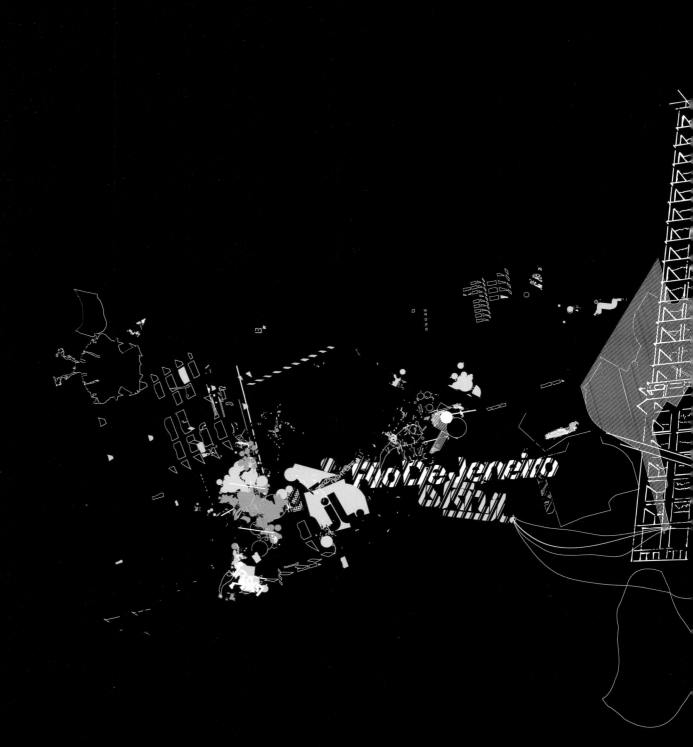

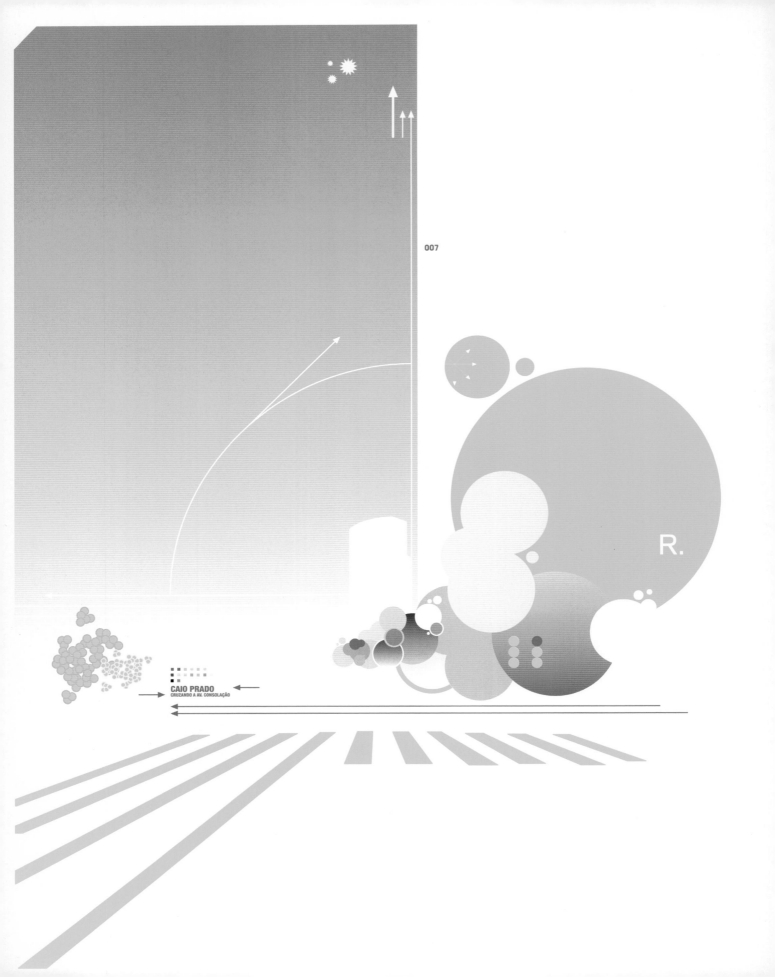

007

R.

CAIO PRADO
CRUZANDO A AV. CONSOLAÇÃO

ANTONIO CARLOS

R.

002

Av.

PAULISTA

Pç.

ROOSEVELT

LUSTRES

DOS

R.

MATIAS AIRES

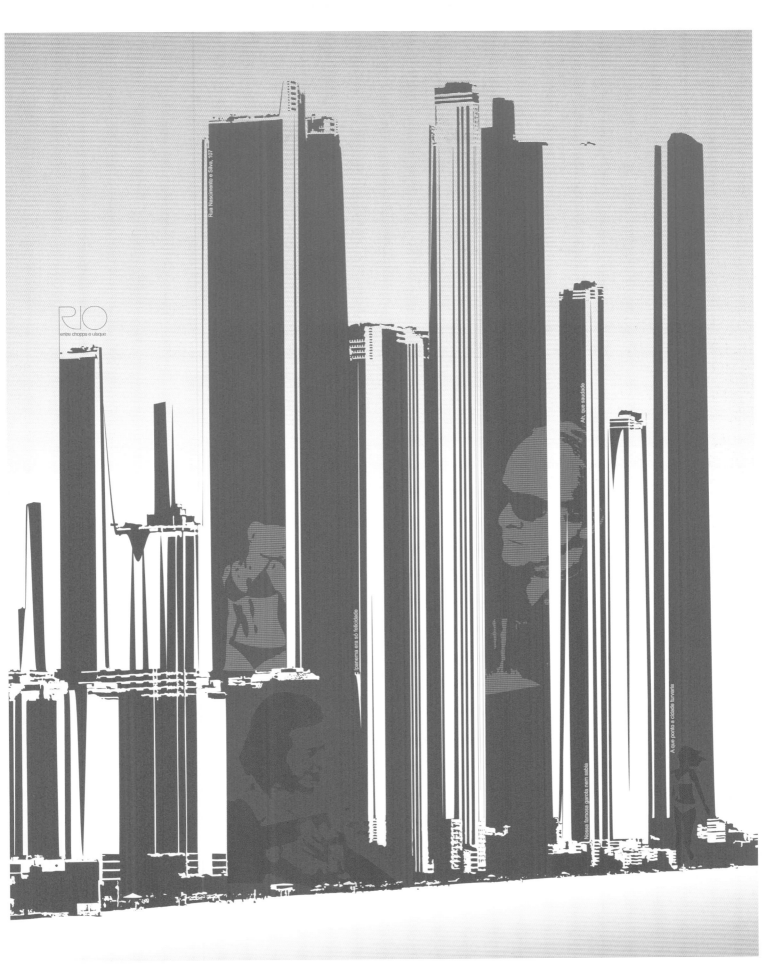

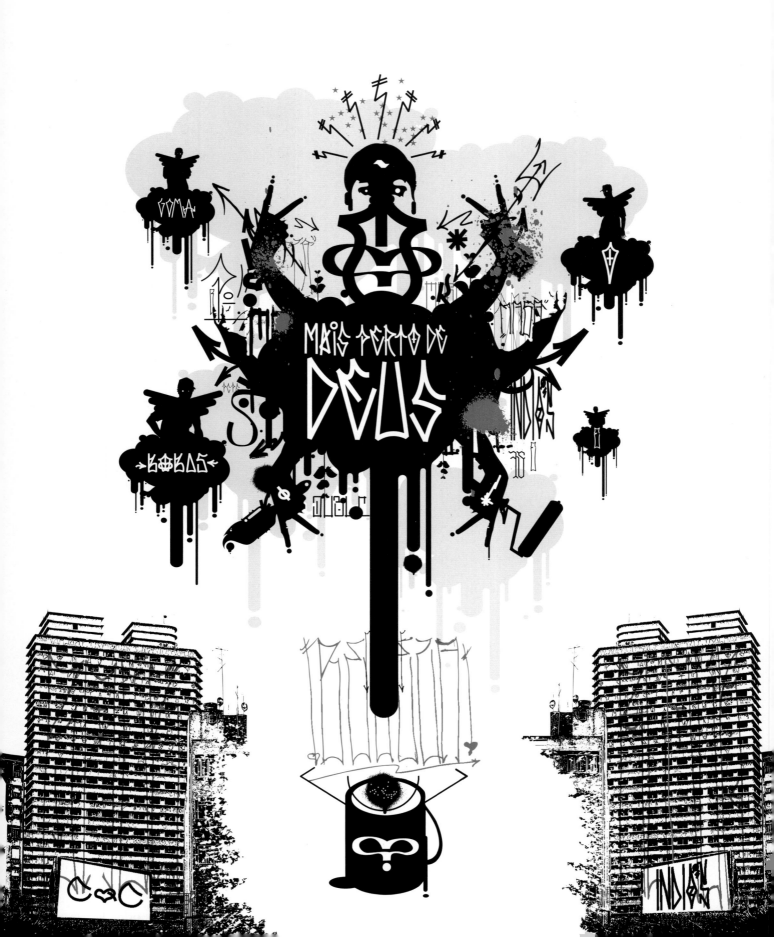

ABCDEFGHIJKLMNOPQRSTU
VWXYZ 1234567890 Nato!*

ABCDEFGHIJKLMNOPQRSTUVWXYZ 1234567890

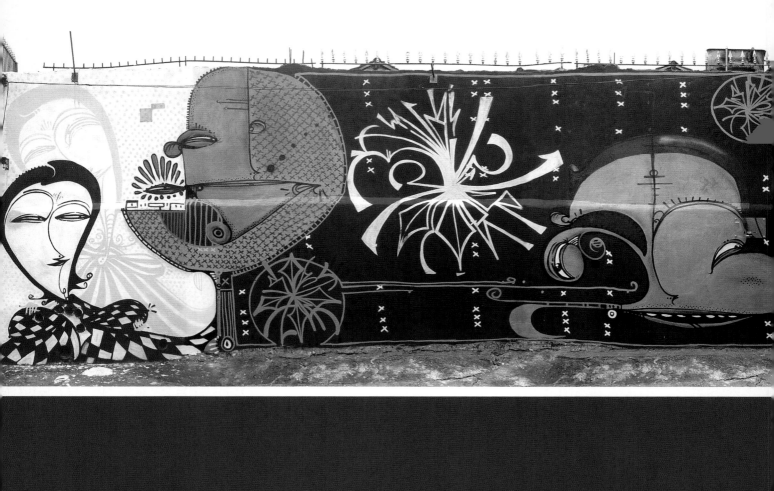

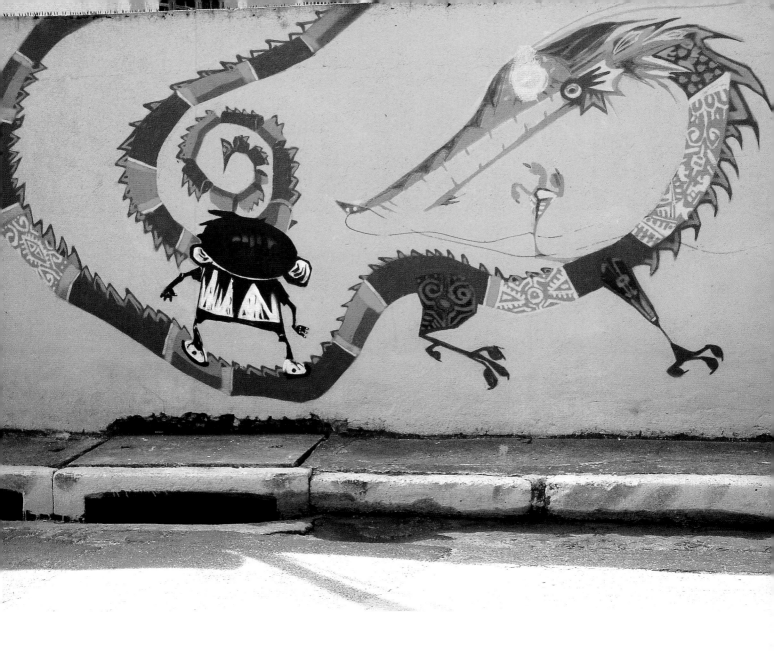

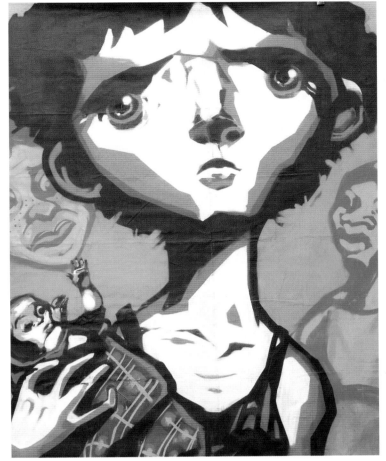

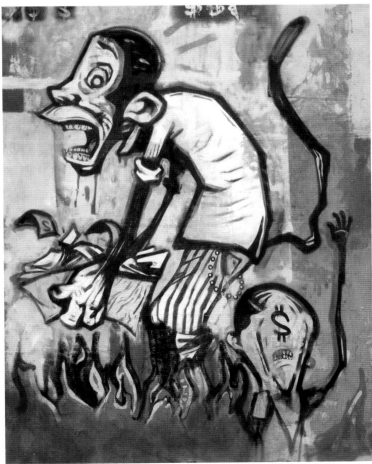

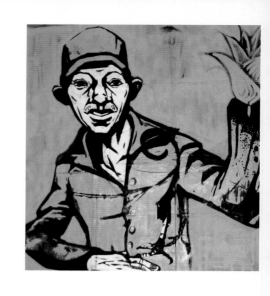

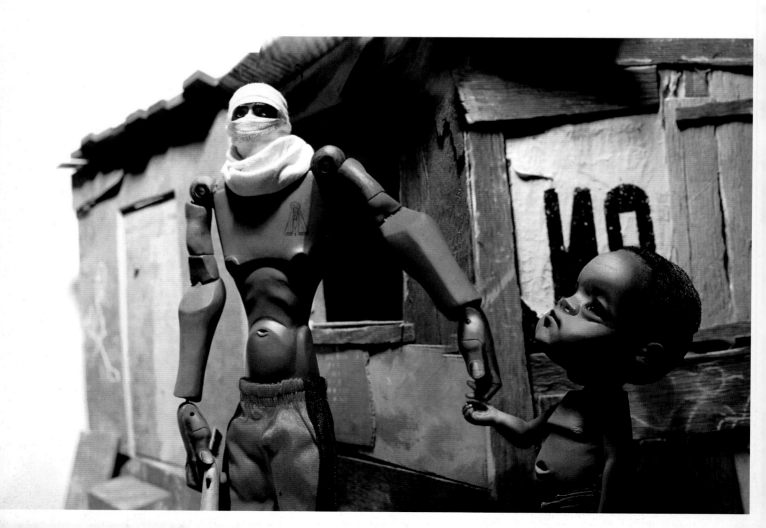

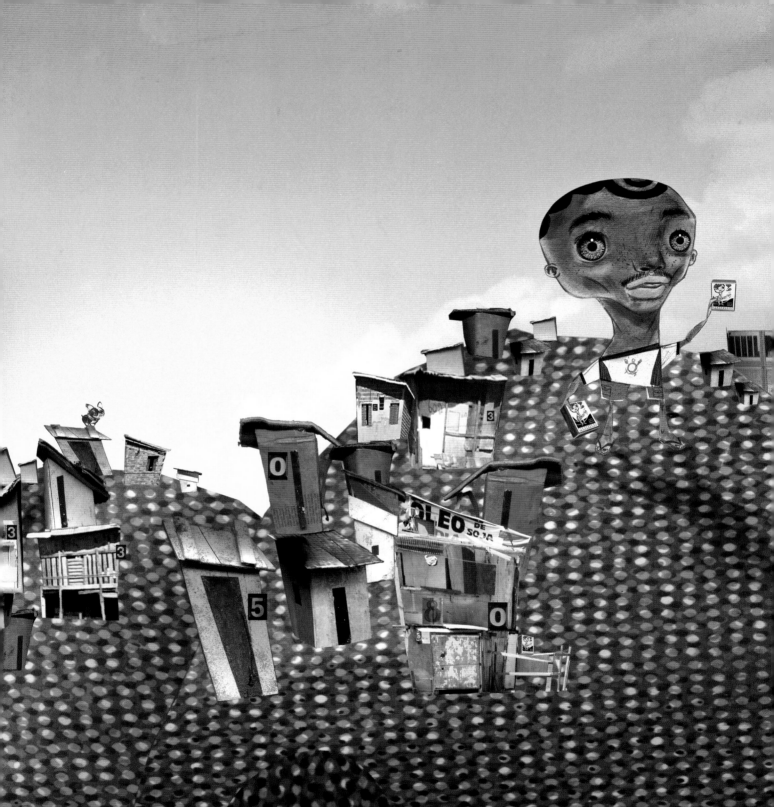

Fósforos Persevero
Levando luz para todos

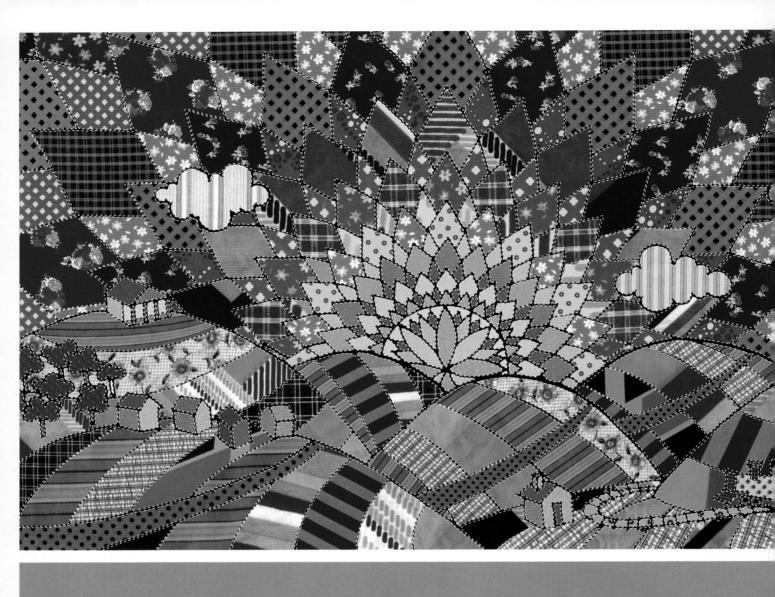

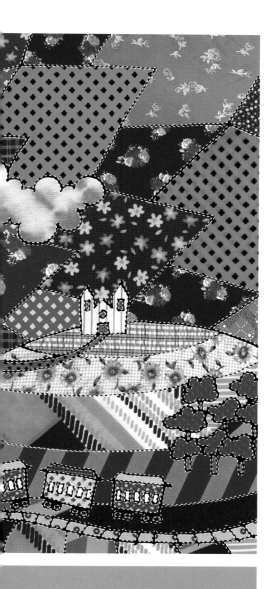

tropical
handgun

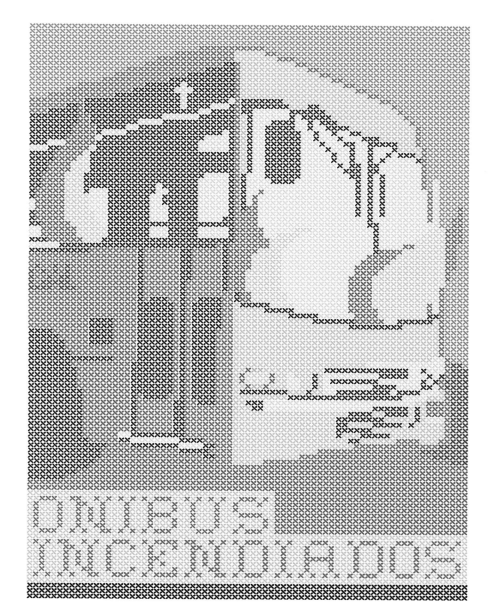

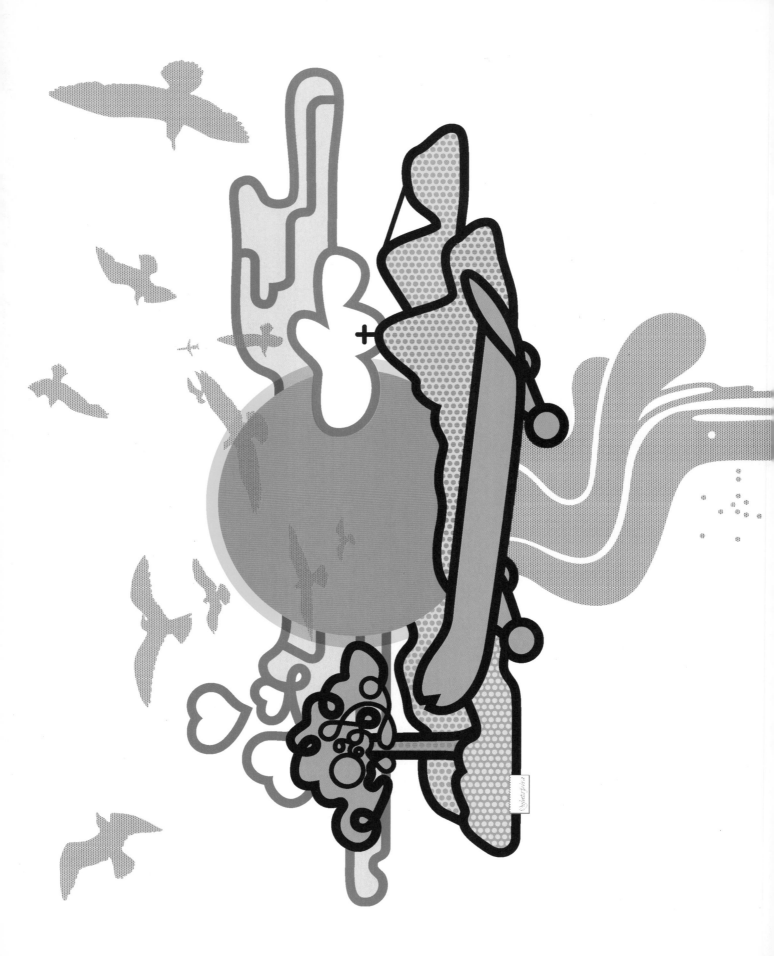

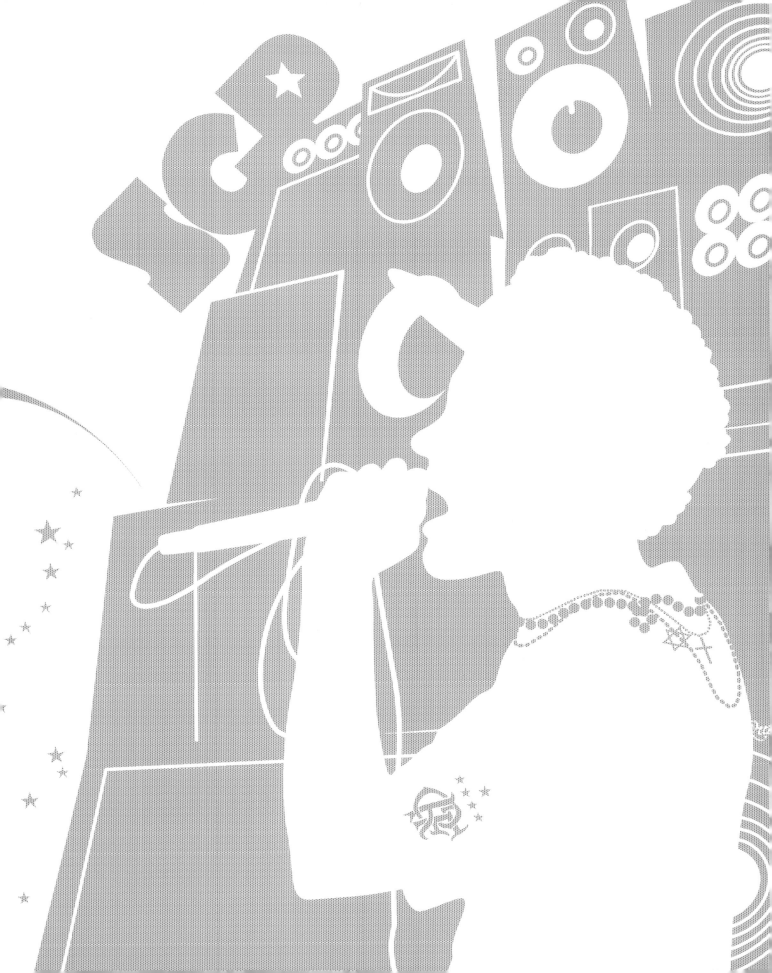

002|003

SWEDEN
002|003_THINGS I THINK ABOUT WHEN I THINK ABOUT BRAZIL
It is just wallpaper designs about Brazil, no more, no less.
credits: SWEDEN
home country: Sweden
email: hello@swedengraphics.com
url: www.swedengraphics.com
date of foundation / birth: 1997
cv / short company history: SWEDEN is a design agency mostly working with graphic design and illustration. SWEDEN is also active part owner of book publishing house "pocky" which publishes non fiction.
what are your inspirations, aims, dreams, and what is your philosophy: not to make interesting design but to make design interesting.
thinking about Brazil - which spontaneous thoughts come to mind: All the things used in the wallpapers are the first things I wrote down on a piece of paper when I first read the brief. Tangas, Concordes, Coffe etc. It is all there.

004|005

006|007

DAVE WEIK / SWEATERWEATHER
004 - 006_UNTITLED
I've always been fascinated by information architecture — graphs, charts, maps and the like. I'm very impressed by designs that can present large amounts of data legibly. That sounds a bit boring, but I believe that, at its core, that's what design is all about, usability. Anyway, that was the inspiration for several of the layouts, but I'm not a total stiff, so I threw a little bit of rocknfugginroll in there for good measure.
Graphic Design / Illustration: Dave Weik
Photography: Faith "Phazer" Purvey
home country: USA
email: david@sweaterweather.org
url: www.sweaterweather.org
date of foundation / birth: N/A
cv / short company history: I received my education in Graphic Design at Lake Forest College and Columbia College Chicago. At Columbia I was given the opportunity to intern at Segura Inc., which I naturally accepted. After 6 months I was hired as an office assistant and now — 5 years later — am Senior Designer. It was a very quick climb and I often found myself in well over my head, but this is the best imaginable way to learn and I was guided by some of the absolute best talents in the industry.
what are your inspirations, aims, dreams, and what is your philosophy: I just aim to do my best and create good work and promote progress in every way that I can.
thinking about Brazil - which spontaneous thoughts come to mind: Honestly, I knew very little about Brazil when I started this project, which probably explains why several of the pieces are based on very factual information — these were the things that I was able to research; it is easy to find data about country, but much more difficult to get an appreciation for its culture.

006|007

008|009

JEMMA GURA / PRATE COMPUTER CHANNEL
007|008_INFERRED TOPOGRAPHY OF BRAZIL.
home country: USA
email: brazil@jemmagura.com
url: www.Prate.com / www.JemmaGura.com
date of foundation / birth: 1972 / MOSAIC
cv / short company history: Prate is an aesthetic exploration produced by Jemma Gura. From 1999 to 2002, Prate offered monthly servings of: force quit processes and broken filters; open directory listings with documentation of activity; command line navigation in perl; open source Illustrator files and Illustrator files to be viewed only in their native app (dubbed "Application Viewing"). Since 2002, Prate has featured a series of inferred and predicted topography (combining gravity data with "Computer Channel" surveys of depth) and other visual ephemera.
Projects such as "MapMaker" at the Whitney Museum Artport with Joshua Davis and "Nitrada - Just Close Your Eyes" at Carrara Biennial, Italy 2002, supplement Prate. In 2000, Ms. Gura co-authored a book which challenges digital artists to force the boundaries of their creative tools.
what are your inspirations, aims, dreams, and what is your philosophy: I listen to a lot of Miami bass.
thinking about Brazil - which spontaneous thoughts come to mind: It has a fine shape.

010|011

012|013

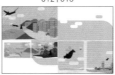

014|015

EIKES GRAFISCHER HORT
010-015_THE HORT IS TAKING CONTROL OVER BRAZIL ON THE NEXT PAGES
credits: eike koenig, martin lorenz, el schindla, tobias röttger
home country: germany
email: info@eikesgrafischerhort.com
url: www.eikesgrafischerhort.com; www.hort.org.uk; www.bolzers.com
date of foundation / birth: 1994
what are your inspirations, aims, dreams, and what is your philosophy: AC/DC
thinking about Brazil - which spontaneous thoughts come to mind: see our artwork we did for the book

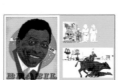

016|017

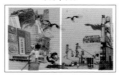

018|019

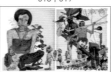

020|021

RAAR / JUDO
016-021_UNTITLED
we tried to show as most different thougths and ideas we had about brasil. We tried also to show the contrast in the country:
The nice playas with the beautiful women, but all dominated by external fabrics and labels. the money who enters through tourists always takes its way back to "first" world countries.
Forest beeing destroyed versus "indigenos" that are beeing robbed their living space.
Metropoles and richness versus exptreme poornes.
And finally pele as *** t h e face of brasil ****,.... nothing to put against.
↘ Judith Ender
home country: Spain / Switzerland
email: judoes@terra.es
date of foundation / birth: 27.09.1976
cv / short company history: 1993-1994 Foundation Course at F+F, Zürich; 1994-1995 Practise at Dynamo Graphic Studio, Zürich; 1995-1999 Apprenticeship at B&B Grahic Design, Zürich
Work: Independent work as graphic designer "judo" since 2000.
↘ Rahel Arnold
home country: Switzerland
email: raar@mails.ch
date of foundation / birth: 06.12.76
cv / short company history: School: 1992-1996 Gymnasium; 1996-1997 Foundation Course at HGK Zürich; 1997-2002 Studies of Visual Comunication at HGK Zürich.
Practise: 2000-2001 Buenos Aires, Argentina: _Tholön Kunst Diseño, _ RSSV, Assistence at the "Universidad de Buenos Aires", facultad de Diseño; 2001 Barcelona, Spain: _ Eumo Gráfic.
Work: Independent work as graphic designer and illustrator "RAAR" since 1997. Teaching graphic design at "Freie Schule für Gestaltung" Zürich, 2002.
Special works: _ Musicvideoclip "Batman & Throbbin" for dj. "Minus 8", 2000; _ Video - Dia Show, "Planetario de Buenos Aires", 2001; _ Musicvideoclip "L.A.Woman" for "Seelenluft", 2002; _ Musicvideoclip "Manila" for "Seelenluft", 2002.
Publications: "Benzin" Young swiss graphic design, Zürich, 2000; "IDN" Grafikmagazin, Hong Kong, 2001; "Vicionary. one:flavour" Graficdesign book, Hong Kong, 2001; "Flips 5, Music vs Motion", Hong Kong, 2001; "Pahtfinder/a/way/through/swiss/graphix", Hong Kong, 2003
what are your inspirations, aims, dreams, and what is your philosophy: I love to work with the most possible different medias at a time: using drawings and graphic animation in a filmed videoclip, ----- combine photographs, illustrator and hand made drawings in a illustration....
my philosophy or my hope is to try going on with "idealistic projects" means: almost always bad (not) payed jobs that take a lot of working time, but projects that aloud me to try out new stuff, i hope never to loose my curiosity and energy to learn and try new things.
thinking about Brazil - which spontaneous thoughts come to mind: I think our work (mine and judos) we did for this book shows best what came spontaneous into our minds!

022 | 023

ASA SHATKIN / SHEBANGDESIGN
022_RAW ART
home country: USA
email: asa@shebangdesign.com
url: www.shebangdesign.com
date of foundation / birth: 11-03-70
cv / short company history: Shebangdesign is Illustration! I am most influenced by children, outsiders, unschooled artists, other illustrators.
what are your inspirations, aims, dreams, and what is your philosophy: Becoming the best illustrator I can. Making a contribution, being a good person. (Not necessarily in that order.)
thinking about Brazil - which spontaneous thoughts come to mind: Economy, forrests, architecture, history, music, dance, soccer, beauty.

022 | 023

JD HOOGE / GRIDPLANE
023_CAFE _FLOPS
home country: USA
email: jd@gridplane.com
url: www.gridplane.com
date of foundation / birth: 2/28/78
cv / short company history: In 2000, JD co-founded the Fourm Design Studio. His work with Fourm received several Flash Film Festival Nominations and the People's Choice Award at FF Amsterdam. In 2001, JD started infourm.com, an online art and design portal and began designing fonts for miniml.com, a digital type foundry. After Fourm, JD has worked independently under the name Gridplane, taught graphic design classes, contributed to flash publications, participated in collaborative gallery events, and has now joined Second Story Interactive Studios in Portland, Oregon.
what are your inspirations, aims, dreams, and what is your philosophy: I just like making things. My real dream is to be a carpenter.
thinking about Brazil - which spontaneous thoughts come to mind: Pele 1962, Avocado tree, Sun burn, flip flops, sand-in-toes.

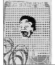

024 | 025

GUSTAVO DELACERDA
024_RINDO
Poster for a fashion collection that talked about the way of the brazillian and latino-americans poor-people: always laughing about their own misery. This image and their elements was also used in clothes and t-shirts.
Graphic Design: Gustavo deLacerda
025_CANTINHO
Poster for a fashion collection. The theme was Rio de Janeiro/ Urban and I worked with stylized images and typography of the "botequins" (typical brazilian bars). This image and their elements was also used in clothes and t-shirts.
Graphic Design: Gustavo deLacerda
home country: Brasil
email: gustavo@substantivo.net
url: www.substantivo.net
date of foundation / birth: 12/08/76
cv / short company history: what is here now, is already past
what are your inspirations, aims, dreams, and what is your philosophy: I like to see and to hear. Sometimes I like to talk and to touch.
thinking about Brasil - which spontaneous thoughts come to mind: culture

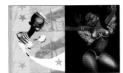

026 | 027

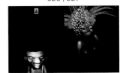

028 | 029

PAULO CÉSAR SILVA / SPETO
026_A TAÇA É NOSSA! 027_MULATA 05
028_DEVOTO DE NOSSA SENHORA 029_MULATA 03
030_MULATA 02 031_MULATA 01
To create, I relate to my visual and emotional experiences, my surroundings, and world issues as well.
I research a lot on brazilian art and mixed techniques, but when I start a work, I let my intuition to take control.
My character's eyes are an important aspect about my work, a way to create a binding between the art and the people who is seeing it.
home country: Brazil
email: speto@ speto.com
url: www.speto.com
date of foundation / birth: December, 19th, 1971
cv / short company history: Speto started to draw as a kid and, as he grew up and expanded his horizons, he decided to explore, by skateboard, the streets and its possibilities. Graffiti was the natural means he found to express himself and the universe he chose to live in.

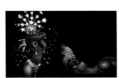

030 | 031

↘ 123 - 127

His first works were published in skateboard magazines in 1987. From then on he has been conceiving, besides logos, T-Shirt and board graphics, also adds and illustrations for practically every Brazilian skateboard mag [Yeah!, Overall, Skatin' and Tribo].
But his Art pleases a wide range of people, of various ages and social classes, so he has been illustrating titles such as Bizz, Capricho, Fluir, Simples!, Trip, Venice, Vip and Vogue R.G., and the newspapers O Estado de São Paulo and Notícias Populares.
Music has also always been, more than a source of inspiration, one of the main elements of Speto´s life and he went from painting panels for a lot of bands to use in live performances to designing record covers and conceiving logos for the bands and labels, among which are: Charlie Brown Jr., Curupira, Nação Zumbi, Nouvelle Cuisine, O Rappa, Planet Hemp and Raimundos, as well as a series of reggae compilations; Matraca and Banguela.
Concerning video clips, he was the Art Director and developed the characters of the animation in "Queimando tudo", by Planet Hemp and Marcelo D2´s solo album, "Eu não sei" by Ira! and he was responsible for the conception of the dancing puppet in the several times awarded clip "Instinto coletivo", by O Rappa. With this band alone, Speto has worked for three years, during which he used to paint murals in live performances, created sceneries and covers. Even Alice Cooper had one of his graffities on stage.
He was one of the artists selected to create a package for Free cigarettes Special Pack series; he signs the animated overture of "Para ser feliz para sempre", a short film awarded in two Brazilian Festivals; During the last edition of Bienal de São Paulo, the most important artistic event in Brazil, he colaborated with two interventions; one of them was exposed on the outside and another one on the inside of the pavillion.
He has also been the Art director of an annual event called Red Bull Hip Hop Rua.
He took part on a graffiti meeting in Chile, on a tour in Argentina, on an international theater show organized by Unicef in Germany and travelled with O Rappa on tour in Portugal
what are your inspirations: The human being, Culture as a whole, specially folklore and folk art in general.
aims: To reach an universal language which sense is captured, not only by insiders, but by non experts as well;
To work with as many different media as possible. It doesn´t matter the vehicle or the means I choose for a specific work, as long as it touches or reaches people in some way.
dreams: I would like to live long enough to see the day Art occupies a larger and better room than it does now.
And it would be great if I could use it an instrument to help or, at least, inspire people.
and what is your philosophy: Facing Art as something tangible and non sacred; dismistifying it and bringing it closer to the masses.
thinking about Brasil - which spontaneous thoughts come to mind: Contrast, diversity, variety...
I feel that being born here is a privilege and I´m proud of it. Our people has the ability to exorcise every negative feeling, such as fear, pain, hunger and poverty through artistic manifestation.

TUCA REINES
032 - 035_ESTEVÃO HOUSE
Show news spaces in a particular views.
home country: Brasil
email: tucareines@tucareines.com.br
url: www.tucareines.com.br
date of foundation / birth: 11 july 1956
thinking about Brasil - which spontaneous thoughts come to mind: The simplicity and happyness like Brasilian Style

032 | 033

034 | 035

036 | 037

JULIO DUI / MONO
036_DOMÍNIO PÚBLICO 1,2 / _PUBLIC DOMAIN, 1,2
probably I am trying to understand and to add something in my culture.
illustration and design: Julio Dui
home country: Brazil
email: dui@mono.com.br
url: www.mono.com.br
date of foundation / birth: 1999
cv / short company history: Mono → do not run like a base office, runs like a signature for works that was not produced within comercial effect.
what are your inspirations, aims, dreams, and what is your philosophy: to live and make it worth it.
thinking about Brasil - which spontaneous thoughts come to mind: I prefer to think more politically than spontaneously.

036 | 037

MARIO SADER
037_ANA ROSA, 1998
photo by mario sader
home country: Brazil
email: msader@mac.com
url: none yet
date of foundation / birth: 20.01.74
cv / short company history: work as a designer for Lobo since 1999.
what are your inspirations, aims, dreams, and what is your philosophy: My inspirations changes from time to time, since my interests change, my references, what moves me, etc... But mainly I try to transmit feelings through images.
thinking about Brazil - which spontaneous thoughts come to mind: Where I live and where my family is.

038 | 039

040 | 041

RINZEN
**038 - 041_RINZEN:BRAZIL 1 _RINZEN:BRAZIL 2
_RINZEN:BRAZIL 3 _RINZEN:BRAZIL 4**
Symbiotic relationships & predatory relationships.
Design: RINZEN
Photography: Lyn Balzer and Anthony Perkins @ Creative (Sydney)
Scanning: Screen (Sydney)
Models: Lauren @ Chadwick (Sydney), Lindsay @ Chadwick (Sydney), Ross @ Face (Sydney)
Makeup and Hair: Angela Davis-Deacon @ DLM (Sydney)
home country: AUSTRALIA
email: they@rinzen.com
url: www.rinzen.com
date of foundation / birth: 2000 A.D.
cv / short company history: Rinzen is a 5-person design collective, working on a range of client and personal projects - in print and web design, illustration, fonts, characters, animation and music.
what are your inspirations, aims, dreams, and what is your philosophy: Viva La Vector
thinking about Brazil - which spontaneous thoughts come to mind: Colour, wildlife, rainforest, parties, people.

042 | 043

DANIEL PIWOWARCZYK
042_UNTITLED
all photos by Amanda Marsalis

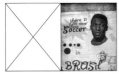

042 | 043

↘ 061 - 062

EDUARDO RECIFE / MISPRINTEDTYPE
043_THERE IS A LOT MORE THAN SOCCER IN BRAZIL
Seems like people just know brazil from our soccer history. We are/have a lot more than that to offer.
country: Brazil
email: recife@misprintedtype.com
url: www.misprintedtype.com
date of foundation: 1997
CV: +_features/contributions/press/interviews: 55dsl & faesthetic: contribution for show/book; american design awards: accolade award; animalism: interview; bd4d: news poster; beast: contribution; black tipografico: interview; bo.ssa: contribution; cassandra fax project: contribution; computer arts "typography special": 3 typefaces for the cd; cromatics: double page spread; digital video world: 3 typefaces for dvd; estado de minas: newspaper article; expo

arte digital: collective exhibition in rio; faesthetic: contribution; forward mag: contribution; form&form mag: contribution; funkworks: interview and contribution; great graphics on a budget: featured on book; items: dutch mag, featured site review; jpeg: contribution; minima: cover and contribution; narancic.grafika: cards project contribution; naughty bits: contribution; plastikid(rodeo27): contribution; regles:zero: interview and contribution; sfaustina: tshirt collab; simples: comissão de frente_ 5 pages; siue exhibition: 4 postcards contribution; strukt: contribution; suite 72: contribution; tartart: contribution; tiger: contribution; xperiments (korea): interview
+-clients: nakd, simples, revista vip, david barringer, digitaria, etc...
what are your inspirations, aims, dreams, and what is your philosophy: Continue to improve and develop my work.
thinking about Brazil - which spontaneous thoughts come to mind: A beautiful place, perfect weather, beautiful people, but ruined by a few selfish and ignorant people.

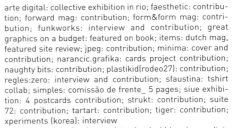

044 | 045

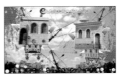

046 | 047

048 | 049

050 | 051

FRANÇOIS CHALET
044 - 051_TOURIST IN BRASIL
to make a contribution about brasil I decided to go to brasil. My ideas came from there. It's my personal interpretation of what I (and my grilfriend) saw. It's a kind of diary. please enjoy.
credits: françois chalet;
www.francoischalet.ch; www.primalinea.com
home country: Switzerland
email: bonjour@francoischalet.ch
url: www.francoischalet.ch
date of foundation / birth: my birth 1970, birth of my one-man company 1996
cv / short company history: I'm a cat since 1996. From then on I worked for different clients making illustrations, animations, direction and graphic-design. My clients are: mtv germany (mtv-alarm campaign, 1998), mtv uk (mtv european music awards, 2001), expo 02 (CH-campaign for swiss national fiesta, 2002), op-vodka (U.S.A.-2002), resolve (uk, 2002), mitsubishi (www.world-wagamama.com, 2003) ...
what are your inspirations, aims, dreams, and what is your philosophy: everything is inspiration, I want to do a one and a half hour animation film (aim), I want to do a one and a half hour animation film (dream), and I don't have any philosophie I just do what I feel right.
thinking about Brazil - which spontaneous thoughts come to mind: beautifull! (ihla grande), poor-rich (salvador de baia), cheap (for tourists), mosquitos (I hate them!), too hot (for me), lula (he is cool), and all I show in my artwork.

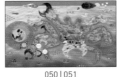

052 | 053

BRIAN TAYLOR / XL5
052_CARMEN MIRANDA 053_PAINTING BY NUMBERS
credits: © Brian Taylor 2003
home country: Scotland
email: brian@XL5design.com
url: www.XL5design.com
date of foundation / birth: 1960
cv / short company history: I've worked for many years as an illustrator under my own name 'Brian Taylor', but XL5 is not exactly a company, it's the collective name for my own personal projects. The first real job to come under the XL5 banner is my book, 'RUSTBOY-(re)animating a lifelong dream' published by XL5 Editions.
what are your inspirations, aims, dreams, and what is your philosophy: To make a reasonably comfortable living from working on exactly what I want to do, in the way I want to do it. I'm pretty much doing that right now with my Rustboy project.

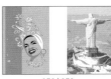

056 | 057

SEAN DONOHUE / GOINGONSIX
056_MOLUMBO FOR CAVALERA 057_VALE TUDO FOR FIGHTING
home country: US
email: sean@goingonsix.com
url: www.goingonsix.com
date of foundation / birth: 1998
cv / short company history: Goingonsix.com is the personal / journal site of Chicago, Illinois based designer Sean Donohue. Goingonsix functions as a playground for Sean's explorations into narrative through motion graphics and interactivity online.

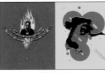

Sean is currently a senior designer with Semaphore Partners Chicago working on projects for Purina, USG and Chemistri. Prior to joining Semaphore he served as the senior designer for New York based studio HUGEInc. At HUGE, Sean lead projects for clients such as IKEA, Bad Boy Records and Mario Lalich Photography.
Sean holds a B.F.A. in graphic design from Oswego State University.
thinking about Brazil - which spontaneous thoughts come to mind: Two things - Jiu Jitsu and Max Cavalera. Jiu Jitsu because of the many hours spent watching no-holds barred fighting tapes with friends and actually having a friend who was involved with it. Max Cavalera was the main man behind the famous Brazillian heavy metal band Sepultura. Roots, Bloody Roots.

058 | 059

060 | 061

TATIANA AROCHA / SERVICIO EJECUTIVO
058 - 060_BRASILEIROS TRADING CARDS
set of 7 trading cards of the brazilian diaspora based in New York city.
credits: tatiana arocha
home country: Colombia
email: tatiana@servicio-ejecutivo.com
url: www.servicio-ejecutivo.com
date of foundation / birth: November 2001
cv / short company history: Servicio Ejecutivo started with the idea of putting my portfolio online, but I didn't like the thought of having a web site just about myself, so I decided to make it into a gallery that could serve as a source of inspiration for people around the world, showcasing different artists from different fields around the world. It is now growing into a company that involves the collaboration of other artists in producing work for broadcast, print and web.
what are your inspirations, aims, dreams, and what is your philosophy: to create design that is fun and playful, that people can identify with and relate to, and that leaves open an environment for collaboration.
thinking about Brazil - which spontaneous thoughts come to mind: beautiful and happy people, a colorful country, great architecture and more....

060 | 061

062 | 063

EDUARDO RECIFE / MISPRINTEDTYPE
061 - 062_BIRDS, FLIES AND PLASTIC FLOWERS
Its a serie of images showing how Brazil is disrespecting and giving away the nature beauty in order to build big cities filled with trash and flies. Why plant a flower if you can just buy a plastic one at the supermarket?

↘ 043

062 | 063

BÜRO DESTRUCT
063_BD IN BRAZIL / WILD CAT
credits: Terry Gilliam
home country: switzerland
email: bd@bermuda.ch
url: www.burodestruct.net
cv / short company history: With the aim to encourage and promote young artists, HGB Fideljus created the Destruct Agentur in 1992. Teaming up with graphic-designer Lopetz in 1994, the "art agency" changed into the graphic design bureau destruct or "Büro Destruct", as it is known today. The current crew counts 5 members: (MBrunner, H1reber, Heiwid, Moritz and Lopetz).
The design work of BD consists of a larger part of print matter with a range from corporate identities, logotypes, ads, books, record-sleeves / cd-covers, posters to flyers...
A speciality of Büro Destruct is creating typefaces since 1995. The fonts can be accessed on the büro destruct font-

foundry-website called typedifferent.com opened in february 2002.
The 1999 book "büro destruct", published by "Die Gestalten Verlag" in Berlin, Germany, offers a sort of retrospective on the bureau's work from 1994 to 1999. The ever so popular "Electronic Plastic" book in 2000 is followed up in 2001 by the project: "Narita Inspected" a roundup of contemporary graphic designers in Japan, researched and designed by Lopetz/BD. In summer 2003 büro destruct is releasing their second book with works from the last four years.
2002 büro destruct launched "Loslogos.org" an internet project where visitors can upload logos from the streets all over the world into loslogos city to protect them from disappearing.
Also in 2002 büro destruct opened their small but nice graphic-design-shop called "büro discount" in Zürich. An online-shop is ready to follow in 2004.
Even though the Büro Destruct often seems weird and precise enough to be Japanese, they're still located in Berne, the small and unsuspecting capital of Switzerland.
what are your inspirations, aims, dreams, and what is your philosophy: - invent - create - inspire - retire. all that with an eerie smile in the face.
thinking about Brazil - which spontaneous thoughts come to mind: goals, samba de amigo and wild cats.

064 | 065

ANDRE MATARAZZO
064 | 065_LIFE IS SIMPLE
At the time I was living in Vancouver and it was a time in my life where I was trying to go back to the basics, simplify my habits, stop rushing, stop desperately needing to achieve certain goals. And I kept imagining the perplexity of a Brazilian native as he encounters a developed world - Canada - with its tall people, clothes, computers, phones, stadiums, cars, snow... I wonder if he would feel the need to have any of that to be satisfied and live in peace.
credits: Andrew Rowat - photography
home country: Netherlands
email: maximo23@yahoo.com
url: xururu.org
birth: 12/05/74
cv: McCann-Erickson - Sao Paulo / Blastradius - Vancouver/ Blastradius - Amsterdam. Likes the cello and doesn't like self-promotion.
what are your inspirations, aims, dreams, and what is your philosophy: To learn, continuously... a new language, a new instrument, a new art form, new people, to see, to keep the eyes open, to keep the soul open. My dream is to become a great musician or visual artist and touch people, even if just for a few minutes. Want to have some decent money in the bank and then spend it all traveling and giving it to the people I love. Ultimately, I try to live the present and not make too many plans for the future.
thinking about Brazil - which spontaneous thoughts come to mind: Brazil is where I grew up at. Brazil is a country that can captivate so many hearts and have so much beauty and amazing people and love and warmth... while being a real social mess. How can people live with the fear of getting shot as they walk down the street for no reason at all and yet smile, party, take care of their bodies and soul, prey, dance and love? Brazilians can.

066 | 067

MK12
066 | 067_MACHO BOX
When we first started working on this project, our initial idea was to make a piece about machismo in Brazilian culture. However, after a few days of working, we realized that we in fact knew very little about 1) Brazil, and 2) machismo. Turning lemons into lemonade, we decided that we would let the theme of the piece dictate its direction, and we positioned ourselves as interpreters, not manufacturers. We consider this piece our attempt at "graphic journalism" -- a slice of reality enhanced and retold in a graphic context.
home country: USA
email: info@mk12.com
url: www.mk12.com
date of foundation / birth: Summer 2000
cv / short company history: MK12 is an artist collective and design lab based in Kansas City, MO. Founded by art school fugitives Ben Radatz, Jed Carter, Matt Fraction and Tim Fisher, MK12 showcases their work at www.mk12.com, imaginatively enough. This innovative and critically acclaimed company debuted on CBS October 3, 1961 and ran until September 7, 1966. MK12 centers on the life of a New York comedy writer who lives in New Rochelle with their wife Laura and son Richie. There are some wacky next-door

062 | 063

neighbors. MK12 is the Head Writer of the Alan Brady Show and shares an office with writers Buddy and Sally. The team works under Mel Cooley, the balding, sarcastic producer of the show that no one really likes. MK12 frequently trips over the ottoman.

what are your inspirations, aims, dreams, and what is your philosophy: Our only goal is to continue doing work that is both creatively and intellectually challenging. We're not too sure what that means, but we're working towards it nonetheless.

068 | 069

RYAN DUNN / LIFTINGFACES
068_ABAIXO DE _MENINE DO COGUMELO _MORTE NOVELAS
The series was intended to be an analysis of Brasilian culture. From soap operas ("morte novelas") to the inner city ("abaixo de"), the images represent my internal iconography of what those facets of Brasilia means to me. The style is highly illustrious and graphic, escaping any realistic representations, as my point of view is equally vague and abstract.
Concept and Design: Ryan Dunn
home country: United States by way of Chicago, IL
email: ryan@liftingfaces.com
url: www.liftingfaces.com
date of foundation / birth: 11/27/1977
cv / short company history: Upon leaving art college, I've spent 3 years working in the interactive realm, with jobs at Spike Networks, Juxt Interactive, and Thunk Design. I've attempted my own company with 2 others (Spinalchord), and am currently 2 years into my career as lead designer of Digital Kitchen Chicago, working in the motion graphics industry.
what are your inspirations, aims, dreams, and what is your philosophy: My future plans are to continue designing and learning more about the medium, in whatever form that takes on.
thinking about Brazil - which spontaneous thoughts come to mind: Green. Warm. Diverse. Exotic.

068 | 069

LINN REHMAN COSTA
069 - 075_A BIG PARTY
I didn´t know much about Brazil before I moved here so what I came to think of was carnival, the energy of the music and all the big buts
credits: Linn Rehman Costa
home country: Sweden
email: linn@nakd.tv

070 | 071

url: www.olofsdotter.com; www.nakd.tv
date of foundation / birth: November 3rd, 1978
cv / short company history: Linn Kristin Olofsdotter Rehman Costa was born and raised in Umeå, a small city in the north of Sweden, about 400 km from the artic circle. She did not begin illustrating until recently. Instead, she studied Advertising at Rmi-Berghs School of Communication in Stockholm, as well as Graphic Design both in England, and in Chicago at The School of the Art Institute of Chicago. In 2001, Linn joined the design team of Digital Kitchen in the Chicago office where she worked on broadcast projects.

072 | 073

Currently, Linn is one of the driving forces behind Nakd, a design studio that she's started along with Brazilian Artist and Designer Nando Costa. Linn and Costa, also her husband, work from their studio based in Rio de Janeiro.
In addition to her involvement at Nakd, Linn has successfully delved into clothing design and producing customized accessories. Nowadays she receives requests from customers around the globe, interested in both shirts and bracelets as well as other accessories that she has recently started to create.

074 | 075

what are your inspirations, aims, dreams, and what is your philosophy: My inspiration is all the good people I sourround myself with, especially my husband. At the moment It´s just very exciting building up our new company without worrying so much about the future.
thinking about Brazil - which spontaneous thoughts come to mind: machisimo, tiny clothes, poverty, corrupption, beautiful nature, soccer

INTERVIEW ↘ 072

Artistic Direction & Design: Alexandra Jugovic
Programer: Andreas Müller
home country: UK, London
email: info@hi-res.net
url: www.hi-res.net
date of foundation / birth: 1999

076 | 077

078 | 079

GREYSCALE
080 - 083_UNTITLED
Credits: Greyscale.Net
home country: Sweden
email: contact@greyscale.net
url: www.greyscale.net
date of foundation / birth: founded in 1999
What are your inspirations, aims, dreams, and what is your philosophy: I take inspiration from everything & anything. Like most designers I guess I'm really into good photography, Gary Winogrand, Miles Aldridge, Mary Ellen Mark. Also find glass blowing really interesting, like the work of Dale Chihuly is amazing. In terms of aims and dreams my only hope is that I can keep doing what I'm doing for as long as possible.
Thinking about Brazil - which spontaneous thoughts come to mind: Giant trees, samba & lots of really inspiring designers.

080 | 081

082 | 083

NATHAN FLOOD / NGINCO
084_BRAZIL
Brazil doesn't really exist.
credits: Nathan Flood, Herman Leung
home country: New York, NY USA
email: nathan@nginco.com
url: http://nginco.com
date of foundation / birth: 02/11/80
cv / short company history: Digital Artist/Art Director
Clients include: Mazda, Bacardi, Gucci, Digital Vision UK
Inspirations: New York, Music, Altered states
Aims: Special effects, 3D, Art
Dreams: To travel beyond our known limit
thinking about Brazil - which spontaneous thoughts come to mind: Gisele, Coconuts, Bananas, Waffles, Trees

084 | 085

CARLOS BÊLA
085_MICROVILOSIDADES
the biology of Brasil.
086_CÉU
it's my sky. our sky
086_VERDEAMARELO, AZULEBRANCO
the colors of the vegetation
086_BOITATÁ DESCANSA, BOITATÁ ATACA
boitatá is a snake in fire that rests in daytime and attacks the people at night. It's a tale from the brazilian folklore.
087_RUA TATUÍ
homenage to the street that i lived for 27 years... and the difficulty to find that address.
photos and design: Carlos Bêla
home country: Brazil
email: carlosbela@goldenshower.gs
url: www.goldenshower.gs
date of foundation / birth: July, 26 1974
cv / short company history: begin to work with motion graphics in 1995 at MTV Brazil's promo and graphic department. Since 2000 working at Lobo [www.lobo.cx]. Making music in the spare time.
what are your inspirations, aims, dreams, and what is your philosophy: Oh.... that question again. My goal is to have fun, always!
thinking about Brazil - which spontaneous thoughts come to mind: A great country with lots of problems wich made it even better and creative. I'm proud of my country.

084 | 085

086 | 087

088 | 089

KEITA SOEJIMA
088 | 089_UNTITLED

102 | 103

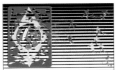

090 | 091

MARTIN WOODTLI
090 | 091_UNTITLED ART
home country: Switzerland
email: martin@woodt.li
url: www.woodt.li
date of foundation / birth: 22/12/71
cv / short company history: Martin Woodtli was born in Berne/Switzerland in 1971, first studied graphic design there at the College of Design Academy before continuing his studies as of 1996 at the Zurich Academy of Design and Art. In New York City, he, which is very well frequent with national and international design-prizes, worked in the offices of Stefan Sagmeister, before founding his own studio in Zurich 1999. Woodtli projects are in the culture sector and he first book about his works was published autumn 2001 by «die Gestalten Verlag» in Berlin/Germany. Switzerland singled him out last year for «The most beautiful Swiss books» and «Book of the Jury»
what are your inspirations, aims, dreams, and what is your philosophy: take less
thinking about Brazil - which spontaneous thoughts come to mind: football

PRAYSTATION
092 | 093_UNTITLED

092 | 093

LOBO
095 -099_SCIENTIA SACRA LUPI
We decided to research our miths and popular beliefs and do animated pieces about it. We were not worried to be very didatic or specific, just do our graphic interpretations of brazilian miths.
Directed By LOBO: Mateus de Paula Santos, Guilherme Marcondes, Cassiano Maluf, Cadu Macedo, Mario Sader, Denis Kamioka
home country: Brazil
email: info@lobo.cx
url: www.lobo.cx; www.theebelinggroup.com
date of foundation / birth: São Paulo, Brasil:1999
cv / short company history: Lobo is a design and animation studio based in Brasil. We're not a collective.
what are your inspirations, aims, dreams, and what is your philosophy: Glue, Blue Moon and Cooper Black.
thinking about Brazil - which spontaneous thoughts come to mind: Not uptight,

094 | 095

096 | 097

098 | 099

INTERVIEW ↘ 094

EDUARDO BERLINER
100 | 101_SACI PERERE AND NO HEAD MULE MADE IN TAIWAN. / SACI PERERÍ E MULA-SEM-CABEÇA PRODUCED EM TAIWAN.
102_CURUPIRA GOT LOST. CURUPIRA PERDIDO
Saci Perere, Mula-sem-cabeça e Curupira are traditional characters from Brazilian folklore. Saci is a dark skinned boy who smokes a pipe and has a magic red hood. He has

100 | 101

a naughty personality. He puts out fire and hide objects inside the house. Mula sem cabeça (No head Mule) is a strong and aggressive animal. Fire comes out of its body. Curupira is a creature that protects the forest and the animals against the hunters. His feet are backwards and because of that, hunters get lost following his footprints.
On both of my works, the representation of the characters were based on observation drawings of my body in the reflection of a window or mirror. This kind of drawing puts you in a difficult situation because you need to draw in positions that are not the most comfortable .
This adversity helps to emphasise my intention of devoiding imaginary characters of their magical power, putting them under conditions of vulnerability that belong to human beings, like physical limitation, loneliness and death.
Setting a time limit of one day for each work, and permitting myself to use only objects present in my room. This helps to connect images that belongs to the imaginary world to the real world. Absence of resources forces me to build solutions using objects that belong to my everyday life, giving to them new meaning and function.
home country: Brazil
email: eduardoberliner@hotmail.com
date of birth: 17/08/78
cv: 95 - 00: Graduated in Graphic Design from Pontificia Universidade CatÚlica do Rio de Janeiro - PUC; 99 - 02: Studied art with Prof Charles Watson
Collective Exibition: 01: Rio TrajetÚrias - Funarte and Viuva Lacerda 157, Rio de Janeiro Performance - Little Rabbit. The work consisted of twenty mechanical rabbits without skin and their redesigned packages. During the performance they have been turned on and walked and blinked eyes through the museum.
Ocupation: 02 - 03: Started in October 02 an MA on Typeface design at the University of Reading - UK. Works as a freelance designer.
Inspiration: Memory, limitation of the body, people I miss and things that I do not understand. I am also motivated by a strong necessity to share with people things that I see and vivenciate everyday. (vivenciar is dificult to translate to english. It means things that I perceiv by living throught a situation)
Aims, Dreams and philosophy: Keep on developing my personal work because it is the way I try to understand myself, people and the world I live in. This is how I try to keep myself alive. I wish someone finds a cure for cancer. It is a very aggressive disease.
Thinking about brazil what spontaneous taught came to your mind: As Iím living in England, the first thing that comes to my mind when I think about Brazil is the people that I love. Now I communicate with them by sending e-mails, letters, drawings and talking on the phone. Sometimes I catch my self trying to talk with them in my mind and then I realize Iím talking with myself.
Cleaning products, my dog with a metal structure on its leg to fix a broken bone, broken tile on the bottom of a swimmingpool, red soil and a waste deposit with huge empty packages of ration with a picture of a dog, colours faded by the sunlight. Streets illuminated by a yellowish mercury light, an ambulance in front of the building next to mine with lights turning on the top but making no sound. An old black car parked under the mid-day sun with a metalic shade on the front window to avoid over-heating. Storm approaching from the sea and the sound of thunder echoing on the mountains, a turtle in the ocean showing its face for a second and disappearing. Lucia with red eyes, turtles in card boxes covered by newspaper, lettuce and excrement. Humming bird hitting its head on the window trying to get away. One day I held a dead one in my hand. Its tongue was long, black and thin. In Caraiva there is no electricity, but the reflection of the moonlight on the white sand is so bright that you can identify shapes in the dark. Mrs Stevan ironing clothes and listening to radio stories about love or murder. Waterfall. Airport.

102 | 103

lyrics by **ARNALDO ANTUNES**
103_INCLASSIFICÁVEIS
This song talks about the ethnic mix of Brazil as something particular to the formation of our culture. The lyrics say that we are "black, white, mestizoes, mullatoes, brown, cafuso, mamelucos" and follows on making a mix up of words which intimates the cultural and ethnic integration that happens in Brazil.
credits: font and design by Birga Meyer - thanks to everybody who has drawn a letter!

104 | 105

↘ 130 - 135
INTERVIEW ↘ 105

TONHO / QUINTA-FEIRA
104_UNTITLED
sketchbooks

106 | 107

NANDO COSTA
106 | 107_DEGENERATION
My artwork was created having in mind the millions of families living on the most horrible poverty level and passing this situation on to their next generations. Not a very happy subject but it is something that has come to my attention since I was a child.
credits: Nando Costa
home country: Brazil
email: nando@hungryfordesign.com
url: www.hungryfordesign.com
date of foundation / birth: 23/05/78
cv / short company history: Brazilian native Nando Costa is equal parts designer, painter, sculptor and digital artist. Costa spent his childhood in Rio de Janeiro studying sculpture and painting. While on vacation in Los Angeles, he came across the works of American multimedia artist Bill Viola, whose installations incorporate music, video and graphic arts. Inspired, Costa left university and a position at a small Rio design studio and embarked for the United States, with stops at design shops The WDDG in New York, Iconologic in Atlanta and Digital Kitchen in Chicago, among others.
Primarily self taught, Costa soon developed a distinctive visual style combining elements of his home country the pulse of the music, expertly mixed doses of saturated color and sensual, organic shapes.
In 1999, Nando founded Hungryfordesign, completing projects for Diesel, Nike, MTV and Virgin Records, among others. In addition to his stunning broadcast design work, Costa spearheaded the highly regarded Brasil-Inspired. project (brasilinspired.com). Design companies including Psyop, MK12, Trollback & Co, Lobo, Freestyle Collective, Praystation and others were commissioned to design pieces based on their interpretations of Brazil. The resulting work toured internationally with ResFest and is currently being published by Die Gestalten Verlag and WeWorkForThem.
Together with Mick Ebeling, founder of The Ebeling Group, Costa and Swedish illustrator Linn Rehman, launched Nakd in 2003. Focusing on broadcast, DVD/interactive and motion graphics fine arts projects, Nakd aims to create honest, evocative and emotive branding projects for design-forward clients. For more information visit www.nakd.tv.
what are your inspirations, aims, dreams, and what is your philosophy: My mind used to be locked into the idea of working and developing my carreer further. That is still a priority but it's definitely gradually loosing it's place for just living my life, spending time with my wife, friends and family. Hopefully I will find a healthy balance soon.
thinking about Brazil - which spontaneous thoughts come to mind: My family, the food, the low cost of living, the nature, the violence.

108 | 109

CISMA
108_DESPERDÍCIO
Brazil is the horse for me.
Sound: Paulo Beto
home country: BRAZIL
email: CISMA@CISMA.COM.BR
url: www.cisma.com.br
date of foundation / birth: 1999
cv / short company history: Cisma is illustrator and graphic designer based in São Paulo, Brazil
what are your inspirations, aims, dreams, and what is your philosophy: I don't think I have a good answer for this, this is the things that always changes.
thinking about Brazil - which spontaneous thoughts come to mind: My home.

108 | 109

110 | 111

INTERVIEW ↘ 054 | 055

CLARISSA TOSSIN / A'
109 - 111_SAUDADE DE AMOR
credits: A' . Clarissa Tossin
home country: Brasil
email: clarissa@a-linha.org
url: www.a-linha.org
date of foundation / birth: 2001
cv / short company history: In the begginig A' was only the way I used to sign my personal work. Because A' was created to promote free associations between me and any other kind of artist that is interested in doing colaborative work for a good proposel. But things have been increasing in a more open sense than the experimental one. So nowadays A' is a one-woman-design-studio-concept based on São Paulo/Brasil that usually makes associations to developed any kind of design job.
Anyway A' means my personal way of exploiting design.
what are your inspirations, aims, dreams, and what is your philosophy: keep doing my job, the way I beleive it should be done, for all my life.
thinking about Brasil - which spontaneous thoughts come to mind: my country, my life, Brasília, Havaianas and Xingú... it dosen't really matter.
many different references related to Brasil.

112 | 113

ADAM C. LEVITE / ASSOCIATES IN SCIENCE
112 | 113_NIGHT LIFE
design: Associates in Science
home country: USA
email: info@associatesinscience.com
url: www.associatesinscience.com
date of foundation / birth: AiS began May 1996
cv / short company history: Founded by Adam Levite and Francine Hermelin → print design → movie posters → film festival (RETinevitable) → cd covers → books books books → identity → exhibition design→ t-shirts → motion graphics → music video music video music video
what are your inspirations, aims, dreams, and what is your philosophy: People just like you, making a new beginning. Train, Service, Supply. Welcome Doubt.
thinking about Brazil - which spontaneous thoughts come to mind: favelas

114 | 115

CAROLINA ABOARRAGE / EP DESIGN
114 | 115_CONSOLAÇÃO
Consolação is an avenue where I lived my whole life. I took pictures of evey crossing of the avenue and on everyone of them discribe the part of the space i was interested on. So I built the sequence of that cut.
credits: Carolina Aboarrage _ eP Design
home country: Brasil
email: carolina@epwww.com / carolina@catarse.com
url: www.epwww.com / www.catarse.com
date of foundation / birth: 11/07/1975
cv / short company history: I used to work on the web division of Trama records. At this time I start to develop a more experimental work. When I quit, I started to work with my friend Pipa and months after we opened a studio, eP. Now we have both comercial and experimental projects.

116 | 117

INTERVIEW ↘ 076

FÊMUR
116 | 117_UTOPIA
In 1960, Brasília, the new capital of Brazil, was inaugurated as a symbol for a new era of industrial development promised by President Juscelino Kubitschek. This planned city, built from zero in a desert plateau, should reflect the processes of modernization and growing that were modifying Brazilian urban environments. Oscar Niemeyer, designer of modernist buildings in Belo Horizonte, São Paulo and Rio de Janeiro, was the architect of this utopic futuristic city.
Utopia is a typeface that represents today's Brazilian urban environment, putting in relation the modernist lines of Oscar Niemeyer with chaotic elements that have appeared after the urban explosion of the 60's and the 70's. It recreates the unplanned situations found in Brazilian big cities, where these elements co-exist and modify each other in ever-changing landscapes.
credits: fêmur (angela detanico and rafael lain)
home country: brazil
email: femur@femur.com.br
url: www.femur.com.br
date of foundation / birth: 1998
cv / short company history: Angela Detanico (1974) and Rafael Lain (1973) work together since 1996, developing art and

graphic design projects.

At the moment, they take part at the Pavillon, group of re-search and production based at the Palais de Tokyo, Paris, and share an atelier at Cité Internationale des Arts.

They have shown their work at the Palais de Tokyo, Paris, Ginza Graphic Gallery, Tokyo, Galeria Vermelho, São Paulo, Printemps de Septembre, Toulouse, Kunstwerein Karlsruhe, Karlsruhe, MAM, São Paulo, 13º Festival Internacional de Arte Eletrônica Videobrasil, São Paulo, SESC Pompéia, São Paulo, Festival Eletronika, Belo Horizonte, Itaú Cultural, Belo Horizonte, among others.

Their graphic design works include projects from typefaces to tv channels visual identities, developed to institutions like Associação Cultural Videobrasil, Arte / Cidade, BIG Magazine, MTV and Globosat.

Angela Detanico is a Master in Semiotics and Discourse Analysis by the Pontifícia Universidade Católica de São Paulo, in which she worked as a professor in 2001.

Rafael Lain started his carrer in graphic design in 1994 working for MTV Brazil. He was a co-founder of Burritos do Brasil, one of the most influent Brazilian graphic design studios in the 90's.

Both are co-founders of Fêmur and members of the board of consultants of Associação Cultural Videobrasil.

what are your inspirations, aims, dreams, and what is your philosophy: to always have a critical approach on what we do.

thinking about Brazil - which spontaneous thoughts come to mind: quindim

MASA
118_VINICIUS 119_CHOPPSEUISQUE

Inspired in Rio de Janeiro...Ipanema and the bossanova feeling Saudade de amor

118 | 119

120 | 121_MAIS PERTO DE DEUS

Inspired in "Pinchação" Writing style, only developed in São Paulo-Brasil. Its almost like a sport, where the goal its to go higher, to rise...where no other has gone before...to be closer to GOD.

credits: MASA: _Mais Perto de Deus, _Vinicius: Miguel Vásquez; _ChoppseUisque: Alvaro Bustillos.

home country: Caracas-Venezuela

email: info@masa.com.ve

url: www.masa.com.ve

date of foundation / birth: June,1996

120 | 121

cv/short company history: MASA is Venezuelan graphic collective, based in Caracas that develops visual concepts by mixing and sampling images and ideas created with ANA-LOG/DIGITAL techniques and process; keeping always a strong enfasis in the main references of Latinamerica and the Venezuelan POP culture.

Inspirations: The street itself. it's references, Music Piñeiro, Lavoe, Everything outside the design scene.

aims, dreams, philosophy: do always what makes us happy What we like the most and what we do best.

Thinking about Brasil - which spontaneous thoughts come to mind: A', DenisK, Tohno, Garfield, Havaianas, Mixtura, barrio Libertade, Botafogo, Pão de Queijo, Ave. Paulista. Coxinhas, Beers (Chopps) and Pinchação.

AKENI
122_UNTITLED
photo by MASA

122 | 123

PAULO CÉSAR SILVA / SPETO
123_O MENINO E O DRAGÃO _VAGUABUNDO _AI QUE FOME!
124_POLÍTICO SAFADO 125_JULIE _MICO
126_TOCA _INSTINTO COLETIVO 127_HYDON

122 | 123

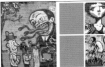

124 | 125

126 | 127

y

↘ 026 - 031

LEONARDO EYER / CAÓTICA
128_PATCH.TIF

Image for a show by "Lo Borges". A traditional singer from Minas Gerais.

Digital Patchwork: Leonardo Eyer, based on a drawing by Bernard Heinburger

129_TROPICAL.EPS

Tropical Handgun is a Personal Music Project

Logo: Leonardo Eyer

129_BURNBUS.EPS

"Ponto Cruz" is a sewing technique very common in Brazil. Our grandmas used to do it representing flowers, fruits and scenes from everyday life. Violence is so big nowadays that "burning buses", "kidnaping", "corrupt politicians" are really part of our lives. So, those are the drawings that should be done today. The "Burning Bus" is the first of a series on violent themes drawn in "Ponto Cruz"

Illustration: Leonardo Eyer

home country: Brazil

email: leoeyer@caotica.com.br

url: www.caotica.com.br

date of foundation / birth: 1997 - 28/10/1969

cv/short company history: CAÓTICA IS A GRAPHIC DESIGN COMPANY. OUR BOOK WILL BE OUT IN DECEMBER. LEONARDO EYER IS A GRAPHIC DESIGNER. GRAPHIC DESIGN IS MY LIFE AND I REALLY LOVE MY WIFE.

inspiration: my surroundings

aim: lose weight

dream: a lowrider

philosophy: It's gotta come from the heart if you want it to work!

thinking about Brasil - which spontaneous thoughts come to mind: Home!!

128 | 129

TONHO / QUINTA-FEIRA
130 - 135_FOUR-COLOR TRANSCRIPTION OF AN INSTATANEOUS PATH OF THOUGHT ON THE PLACE WHERE I WAS BORN AND LIVE UNTIL NOW.

Truth cannot be told, it must be discovered. Enjoy the trip.

credits: Lovetrack: (...) Azimuth, Tim, Jorge, Inumanos, Nara, Moacir, Batatinha, Edison, Carol, Bolinha, Bleque, Eduardo, Cadú, Cla, Julinho, Renatílson, Sabota, Celso, Roberta, Charles, Athos, Afrika, Wilson, Alê, Elis, Clementina, Brown, Luís, Mussum, Didi, Maranhão, Danny, Gilles, Philippe & Stigy, Felipe, David, John, Daniel, Cornel, APC, Catra, MPC, Dênis, Rafael, Mira, Lygia, Hélio, Oscar, Chuck, Tibor, João, J.C., Beastie, Stefan, (...)

home country: Brasil

email: domingo@quinta-feira.org

url: www.quinta-feira.org

date of foundation / birth: 2004

cv/short company history: Seu Paiva and Dona Gessy begun it all 26 years ago with a very simple experiment: mixing semen with an ovule on a pleasureous process.

what are your inspirations, aims, dreams, and what is your philosophy: I'm trying to hold water on a flat surface.

thinking about Brazil - which spontaneous thoughts come to mind: Bonita.

130 | 131

132 | 133

134 | 135

y

↘ 104
INTERVIEW ↘ 105

Edited by Nando Costa, Birga Meyer, Miguel Vásquez and Robert Klanten

Layout and Graphic Design by Birga Meyer
Cover Design by Birga Meyer and Mika Mischler
Executive Management by Birga Meyer and Nando Costa
Brazilian Research by Miguel Vásquez
Production Management by Janine Milstrey
Translations and Proof-Reading by Helga Beck

Made in Europe.
ISBN 3-931126-93-5

Bibliographic information published by Die Deutsche Bibliothek
Die Deutsche Bibliothek lists this publication in the Deutsche
Nationalbibliografie; detailed bibliographic data is available in the
Internet at http://dnb.ddb.de.

© dgv - Die Gestalten Verlag, Berlin · London, 2003

more information: www.die-gestalten.de

Special thanks to all contributors as well as to those who did
not make it into this book; and to Joe Shepter, Paul Matthaeus,
the ICBRA in Berlin, Luiz Bernardes, Monika Schulter and
Gil Goes de Araujo.

5193 49